VIENNA 1900

VIENNA, SCOTLAND AND THE EUROPEAN AVANT-GARDE

PETER VERGO

With contributions by George Dalgleish, Jane Kidd, Hugh Cheape
and Elizabeth Wright

National Museum of Antiquities of Scotland

Edinburgh
Her Majesty's Stationery Office

SOURCES OF PHOTOGRAPHS

Akademie der bildenden Kunste: Pl. 8
Bildarchiv der Oesterreichischen
Nationalbibliothek: Fig. 1, 3, 4, 14, 15, 16, 18,
51, 52, 53, 73, 74, 75, 76
Heeresgeschichtliches Museum: Fig. 2
Historisches Museum der Stadt Wien: Pl. 1, 2, 4,
28; Fig. 17
Oesterreichische Galerie & Galerie Welz: Pl. 7
Oesterreichisches Museum für angewandte
Kunst: Pl. 15, 25; Fig. 7, 8, 10, 13, 19, 39, 40, 41,
55, 63, 65, 66, 77, 78
Theatersammlung der Oesterreichischen
Nationalbibliothek: Pl. 27; Fig. 79, 80, 81
British Museum: Pl. 17; Fig. 27, 29, 82, 83, 84
National Gallery: Pl. 16
Tate Gallery: Fig. 44
Victoria and Albert Museum: Pl. 3, 9, 19; Fig. 12,
30, 31, 34, 35, 42, 43, 51, 60
Nationalgalerie, Berlin: Pl. 20
Robert Gore Rifkind Foundation, Beverly Hills:
Pl. 24; Fig. 71
Art Gallery and Museum, Brighton: Fig. 32, 38
Hunterian Art Gallery, Glasgow: Pl. 13, 14
Neue Galerie der Stadt Linz, Wolfgang Gurlitt
Museum: cover
City Art Gallery, Manchester: Fig. 62
Von der Heydt-Museum der Stadt Wuppertal:
Pl. 30
Creditanstalt-Bankverein: Fig. 5, 6
Walter Feilchenfeldt: Fig. 64
Fischer Fine Art Ltd: Pl. 18, 23; Fig. 33, 49, 57,
58, 59, 61, 67
Galerie Michael Pabst: Fig. 21, 26, 28, 50, 56
The Earl of Harewood: Pl. 29
Professor and Mrs Christian M. Nebehay:
Fig. 11
Piccadilly Gallery: Pl. 22; Fig. 22, 23, 24, 25, 46,
48, 54
Whitford and Hughes: Pl. 10

© *Crown copyright 1983*
First published 1983
ISBN 0 11 492333 7

Design by
HMSO Graphic Design Edinburgh

Cover picture: detail from Carl Moll,
Vienna, Naschmarkt and Karlskirche, 1894
1.39

LENDERS TO THE EXHIBITION

Vienna:
Akademie der bildenden Kunste
Bildarchiv der Oesterreichischen
Nationalbibliothek
Bundesmobilienverwaltung
Heeresgeschichtliches Museum
Historisches Museum der Stadt Wien
Kunsthistorisches Museum
Oesterreichische Galerie
Oesterreichisches Museum für angewandte
Kunst
Plan- und Schriftenkammer des Magistrats der
Stadt Wien
Stadtbibliothek
Theatersammlung der Oesterreichischen
Nationalbibliothek

London
British Library
British Museum
National Army Museum
National Gallery
Royal Institute of British Architects
Tate Gallery
Victoria and Albert Museum

Kunstbibliothek, Berlin
Nationalgalerie, Berlin
Staatsbibliothek, Berlin
Robert Gore Rifkind Foundation, Beverly Hills
Art Gallery and Museum, Brighton
Pendlebury Music Library, University of
Cambridge
Hunterian Art Gallery, University of Glasgow
Museum and Art Gallery, Glasgow
School of Art, Glasgow
Neue Galerie der Stadt Linz, Wolfgang Gurlitt
Museum
Public Library, Liverpool
Arnold Schoenberg Institute, University of
Southern California, Los Angeles
City Art Gallery, Manchester
Ostdeutsche Galerie, Regensburg
Internationale Egon Schiele-Gesellschaft, Tulln
Von der Heydt-Museum der Stadt Wuppertal

Albert Beronneau
Collection Ranuccio Bianchi Bandinelli
Creditanstalt-Bankverein
Michael Collins
Georg Eisler
Walter Feilchenfeldt
Fischer Fine Art Ltd
Margaret Fisher
Viktor Fogarassy
Galerie Michael Pabst
The Earl of Harewood
Martin Lang
Dr Rudolf Leopold
Professor and Mrs Christian M. Nebehay
Andrew McIntosh Patrick
Piccadilly Gallery
Nicholas Powell
Dr Wilhelm Schlag
Lawrence A. Schoenberg
Viscountess Stuart of Findhorn
Mary N. Sturrock
Dr E. F. Timms
Dr Camilla Uytman
Peter Vergo
Lord Weidenfeld
Whitford and Hughes
And several owners who wish to remain
anonymous

Major exhibitions and the books that accompany them are supposed to take a great deal longer to organise than has been the case with Vienna 1900. The fact that this has been achieved in barely nine months is due to the tremendous support and enthusiasm we have received from many people.

First, Peter Vergo, Europe's leading expert on the period who, apart from his ready willingness, fortunately had sabbatical leave coming up this year and has devoted himself tirelessly to the project and put at our disposal his encyclopaedic knowledge and his wide range of contacts, not only in Vienna itself but worldwide. His commitment has been matched by the National Museum of Antiquities of Scotland whose staff, under the guidance of the Deputy Keeper, David Clarke, have contributed not only their splendid new galleries but ideas and expertise of many kinds.

In Austria, the Ministry of Science and Research, and the cultural department of the administration of the City of Vienna, have done everything to smooth our path. I would also like to thank all those private lenders, and the galleries and museums both in Vienna and around the world, who have participated. If I single out a few of them it is because of the scale of their assistance. We are greatly in the debt of the Arnold Schoenberg Institute at the University of Southern California, its Director Dr Leonard Stein, and Archivist Jerry McBride, whose advice and encouragement have been invaluable. The Historical Museum of the City of Vienna, the Theatre Collection of the Austrian National Library, the Museum of Military History and the Austrian Museum of Applied Arts have all contributed numerous gems from their collections. In this country Sir Roy Strong and his staff at the Victoria & Albert Museum have been more than generous. We are also grateful to the Robert Gore Rifkind Foundation in Los Angeles, and to the Austrian Institute in London, its Director, Dr Bernhard Stillfried, and Librarian Hannelore Schmidt.

I would particularly like to thank Andrew McIntosh Patrick of the Fine Art Society for his important contribution to the Scottish dimension of this exhibition and for much other help and advice.

Last, but far from least, we must thank the Creditanstalt-Bankverein of Vienna for their financial contribution and most particularly Bruce Dawson who brought us together and helped in so many discreet but invaluable ways.

Vienna 1900 is the result and a tribute to their co-operation.

John Drummond
Director
Edinburgh International Festival

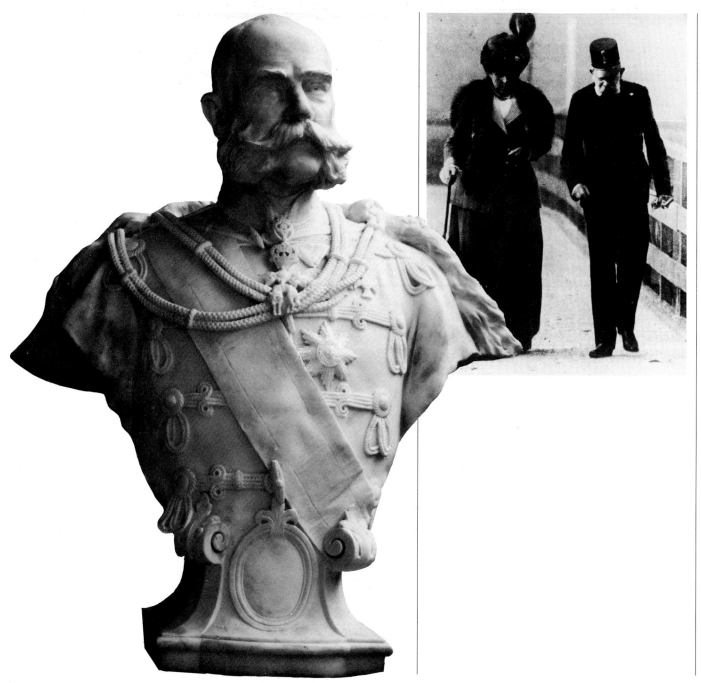

VIENNA 1900

And I fell down and dreamed of irresistible changes . . .
Oskar Kokoschka, *The Dreaming Youths*

His Imperial and Royal Apostolic Majesty Franz Joseph I, Emperor of Austria, King of Bohemia, King of Hungary, supreme ruler in fact of nearly all central Europe, was far from being just a postage stamp monarch. Always in military uniform, his slight figure was a familiar sight in the streets of Vienna, his features, the lined face with the unmistakable mutton-chop whiskers, known to every passer-by. Driving out of the Hofburg, the imperial palace, in an open carriage, meeting some crowned head or foreign dignitary at one of Vienna's railway stations, his life was spent almost entirely in the public eye. When no official visit disrupted his well ordered routine, that life was regulated by a self-discipline as unyielding as the iron army bed on which he slept. Everyone knew the Emperor laboured from dawn to dusk over state papers, the very image of self-sacrifice for the public good. A few people knew, or thought they knew, that behind the mask, away from the endless round of parades and official receptions and birthday celebrations and visits to exhibitions, Franz Joseph was a man of both passion and judgment. Astute enough to accept the compromises political change forced on him, he had enough sense of history, and enough

detachment, to describe himself as 'the last European monarch of the old school.'

But for most, Franz Joseph was a symbol of stability, of an enduring order which seemed all the more rooted in permanence because of the unprecedented length of his reign. In 1898 he celebrated the fiftieth, in 1908 the sixtieth anniversary of his accession to the throne, and the empire celebrated with him. A spate of official and semi-official publications accompanied these imperial jubilees: volumes on the genealogy of the house of Habsburg, fulsome tributes, loyal addresses presented by the university and the academy, by professional associations and artisans' guilds, by ethnic minorities and religious groups such as the Jewish community in Austria. Not to be outdone in this extravaganza of national homage, Vienna itself staged immense street pageants which took hours to file past the official saluting base on the Heldenplatz. Most remarkable of all was the 1908 jubilee procession, in which figures in historical garb passed in seemingly endless parade before an architectural backdrop more like a stage set than anything to be expected in a modern European capital.

In an age already dominated by the photographer and the political cartoonist, it is the art of the engraver and medallist

5

that sometimes provides the most vivid glimpses of Franz Joseph's reign: not only the pomp and pageantry, but more mundane occurrences such as the inauguration of Vienna's fresh water supply, the shooting competition held to mark the Emperor's eightieth birthday, or an event as banal and inescapable as New Year. The various jubilees and anniversaries of course also produced a rash of commemorative plaquettes and medals. Even the Vienna Numismatic Society struck a bronze plaquette to record the imperial jubilee of 1908. More unexpected, and more evocative, is the medal issued by the Austrian Social Democratic Party on the occasion of the 1898 jubilee, commemorating the freedom fighters of 1848—a timely reminder of the fiftieth anniversary not only of Franz Joseph's accession, but of the violent uprising in which the young monarch nearly lost his life.

The spectre of sudden death can never have been far from Franz Joseph's mind. His self-discipline and detachment are all the more remarkable in the face of personal tragedy. His marriage to a Bavarian princess had brought him a beautiful wife and dynastic ambitions; but he can have derived little comfort from his Empress's ceaseless travels throughout Europe, her obsession with her figure, or her near pathological fear of being seen to grow old. In the event Empress Elisabeth was spared the ravages of extreme old age, stabbed to death by an Italian anarchist as she was about to board a steamer on Lake Geneva. Franz Joseph's brother, the Emperor Maximilian, had been executed by firing squad in far-away Mexico. The heir to the throne, Crown Prince Rudolf,

committed suicide in the hunting lodge at Mayerling. Next in line was now Archduke Franz Ferdinand, hated and distrusted by the Emperor not least because of his morganatic marriage. At Sarajevo in July 1914, a bullet aimed at the car in which the Archduke and his wife, the Countess Sophie, were travelling put an end even to these hopes of an orderly succession to the Habsburg throne—and to much else besides.

In reality, the illusion of immutability and permanence created by the centuries-old Habsburg monarchy was at odds not just with the times, but even with the physical environment. The city of Vienna, the Imperial Capital and Residence, was changing, criss-crossed by tramlines and railway lines, the Danube canal regulated by dams, the river Wien vaulted over. As regards the physical appearance of the city, the Emperor himself had initiated the most striking change: the demolition of the old ramparts and construction of a new broad thoroughfare, the Ringstrasse, girdling the inner city (fig. 3). Along this elegant, tree-lined boulevard arose a succession of official and public buildings—the new University, the Town Hall and Parliament, the Court Theatre, the Opera House—so that architectural historians have sometimes likened the Ring to a string of pearls worn about the neck of some fading but still regal beauty. In fact, Franz Joseph's reasons for ordering the construction of the new street were not primarily aesthetic. The Ring afforded the possibility of moving large numbers of troops quickly from one strategically placed barracks or railway station to another, while the Heldenplatz, the square

in front of the imperial palace, was left clear so as to provide a free-fire area—defence not against a foreign invader, but against the threat from the suburbs. With memories of 1848 still vivid no one, least of all Franz Joseph, was likely to forget the enemy closest at hand.

As it happened, before 1914 the Ring was never used for its intended military purpose. On the other hand, its completion brought considerable benefits, not least to Vienna's artistic community. All these new buildings offered countless opportunities for architects and designers and decorators and fresco painters—especially painters: a whole string of commissions for mural paintings and ceiling paintings, historical or allegorical or mythological or all three. Among the painters to profit from this public patronage was the young Gustav Klimt, recently graduated from Vienna's School of Applied Arts. Although during the decade after 1883 Klimt worked mainly in collaboration with others, his hand can be detected in some of the lunettes and ceiling paintings done for Vienna's Burgtheater (1886-8) (fig. 6) and Kunsthistorisches Museum (1890-1). At this date, Klimt seemed destined for a brilliant career as a

Figure 3
Vienna, Ringstrasse with horse-drawn trams
After the demolition of the old city walls in the 1850s, the Ringstrasse became Vienna's principal thoroughfare, girdling the inner city

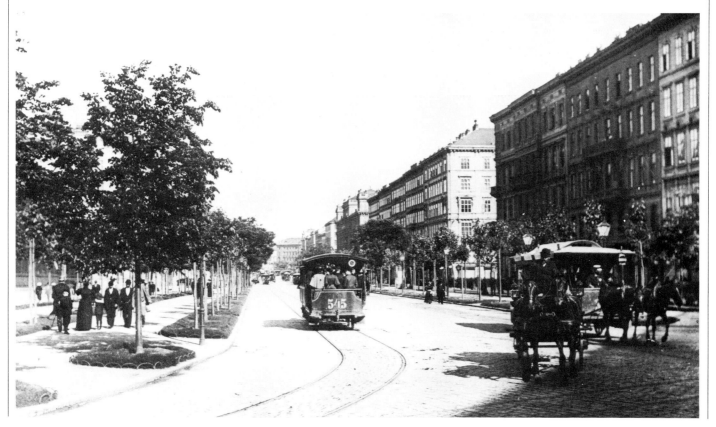

Figure 4
Vienna, The Town Hall

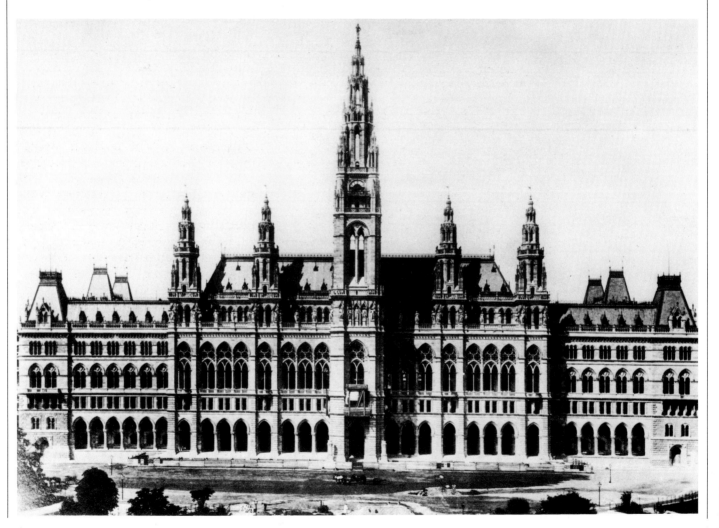

painter of histories and mythologies, a worthy successor to the nineteenth-century Viennese masters such as Makart and Romako. Not even the keenest observer could have foretold the scandals his works of the early 1900s would provoke.

Nearly all of the major buildings on the Ring were completed by the early 1880s, but the vexed problems of Vienna's communications dragged on into the first years of the twentieth century. The main difficulty was that providing the city with a road and rail network adequate for a modern metropolis was indissolubly linked with the tasks of regulating the unpredictable levels of the river Danube and the Danube canal, and the vaulting of the river Wien which, though for much of the year little more than a trickle, cut a trench-like swathe through the very centre of the city. To make matters worse, all these projects had to be taken in hand more or less simultaneously. There was too the question of public opinion. It was widely felt, not least in official circles, that the Stadtbahn, Vienna's new metropolitan railway network, should enhance the appearance of the city instead of just constituting an eyesore. It was therefore proposed that a distinguished architect be retained to oversee this immensely complicated project and pronounce with authority on the aesthetic issues involved. In spring 1894, Vienna's Society of Artists was asked to put forward the name of an architect who would assume overall responsibility for the completion of the Stadtbahn. Their unanimous choice was the then 53-year-old Otto Wagner.

In 1894 Wagner enjoyed a considerable reputation, both in Austria and abroad; but he had built remarkably little. Just how little can be seen by looking at his

Figure 5
Hans Makart
The Death of Siegfried,
1866-68
1.19

Figure 6
Gustav Klimt
Altar of Dionysos
1.21

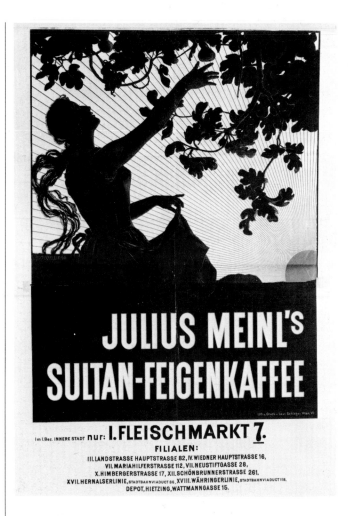

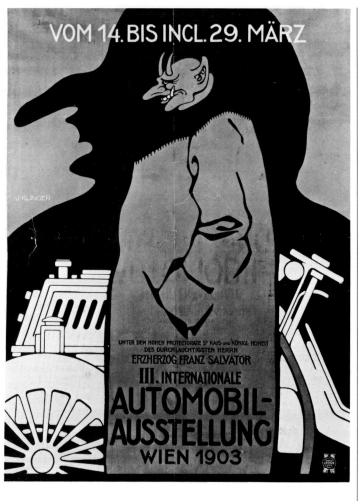

VOM 14. BIS INCL. 29. MÄRZ

UNTER DEM HOHEN PROTECTORATE Sᵣ KAIS. ᵤₙₒ KÖNIGL. HOHEIT
DES DURCHLAUCHTIGSTEN HERRN
ERZHERZOG FRANZ SALVATOR
III. INTERNATIONALE
AUTOMOBIL-
AUSSTELLUNG
WIEN 1903

JULIUS MEINL'S
SULTAN-FEIGENKAFFEE

Im I.Bez. INNERE STADT nur: I. FLEISCHMARKT 7.
FILIALEN:
III. LANDSTRASSE HAUPTSTRASSE 82, IV. WIEDNER HAUPTSTRASSE 16,
VII. MARIAHILFERSTRASSE 112, VII. NEUSTIFTGASSE 28,
X. HIMBERGERSTRASSE 17, XII. SCHÖNBRUNNERSTRASSE 261,
XVII. HERNALSERLINIE, STADTBAHNVIADUCT 86, XVIII. WÄHRINGERLINIE, STADTBAHNVIADUCT 118,
DEPOT, HIETZING, WATTMANNGASSE 15.

Figure 7
Adolf Karpellus
Poster for Julius Meinl's
Sultan-Feigenkaffee
1.51

Figure 8
Julius Klinger
Poster for Third
International Motor Show,
1903
1.52

collection of designs entitled *Einige Skizzen, Projekte und ausgeführte Bauwerke* (Sketches, Projects and Executed Buildings), the first volume of which was published in 1892. Here, one can find Wagner's scheme for the elegant town house he built for himself on Vienna's Rennweg, his country villa and various Viennese apartment buildings; but the projects for which he had submitted unrealized designs—the cathedral in Berlin, the Stock Exchange in Amsterdam, the Parliament in Budapest—far outnumber his executed buildings. It was, however, well known that Wagner was greatly interested in the

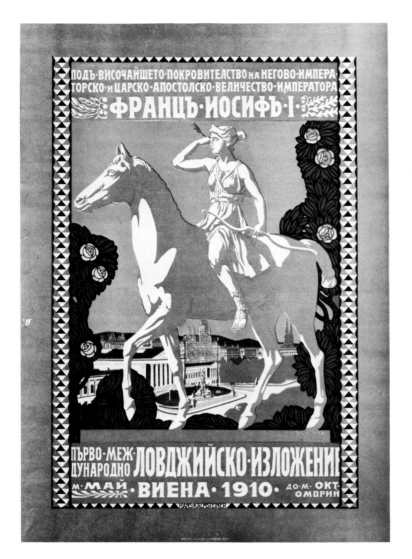

Figure 9
Hans Kalmsteiner
Poster for First International
Exhibition devoted to Field
Sports, 1910
1.53

Figure 10
Kolo Moser
Three designs for banknotes
1.65

technological possibilities offered by
modern building methods and materials
such as re-inforced concrete, glass and cast
iron—a subject to which he devoted a good
deal of attention in the address he delivered
on taking up his appointment as professor
at the academy in the summer of 1894. No
doubt these technological preoccupations

Figure 11
Remigius Geyling
*Otto Wagner and Karl Anton
Count Lanckoronsky*
1.67

Figure 12
Otto Wagner
Chair, 1898-99
1.70

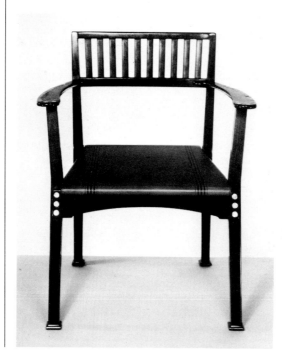

influenced the city's decision to appoint Wagner architect-in-chief for the Stadtbahn project, an appointment confirmed on 22 May 1894. Their confidence was well placed. Though the ornamental detailing of some of the actual station buildings may strike us now as somewhat dated, even fussy, we can still marvel at Wagner's breathtaking solutions to the problems posed by the network as a whole, by the intersection of high-level and low-level lines, lines running across hilly terrain, through cuttings and tunnels, alongside the Danube canal, across bridges and viaducts.

Even before his involvement with the Stadtbahn, Wagner had occupied himself with larger issues of town planning, without—at least as far as Vienna was concerned—enjoying much success. Again and again he submitted proposals for the regulation of the Karlsplatz, where his new Stadtbahn stations stood, as well as for individual buildings such as a new municipal museum or an Academy of Fine Arts—proposals which were rejected outright, or consigned to limbo. None the less, by 1910 Wagner and his pupils had left an indelible mark on the face of the city: not only the Stadtbahn buildings but dams and bridges, private houses and apartment blocks, as well as the jewel-like church built for the Lower Austrian Sanatorium and Institution 'am Steinhof', the finest example of *art nouveau* sacred architecture anywhere in the world. With the completion of the first phase of his Post Office Savings Bank (*Postsparkasse*, 1904-6), for which he designed his own furniture, Wagner also provided the city centre with its first unmistakably modern public building.

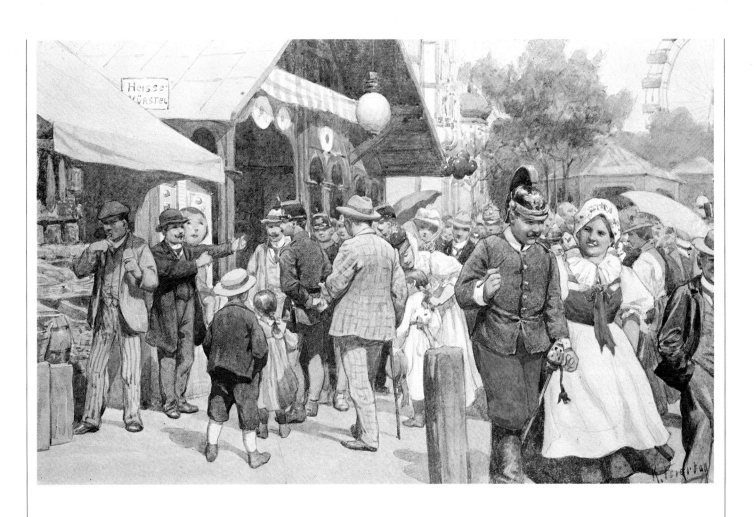

Plate 1
Karl Feiertag
In the Wurstelprater
1.33

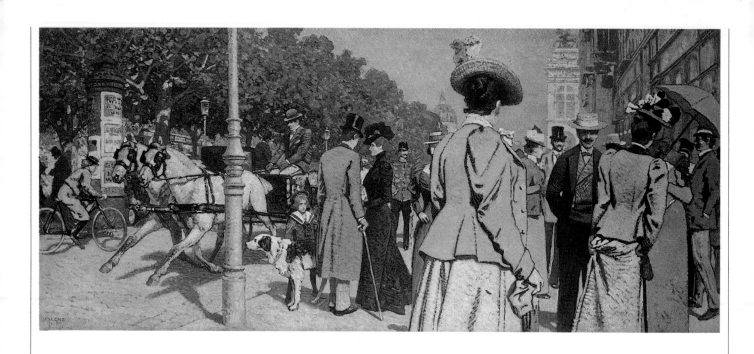

Plate 2
Maximilian Lenz
Sirk-Ecke, 1900
1.36

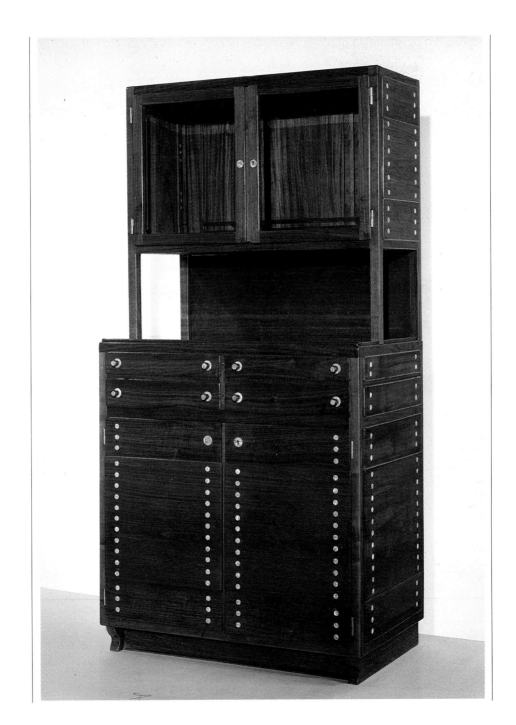

Plate 3
Otto Wagner
Glazed cabinet, 1898-9
1.70

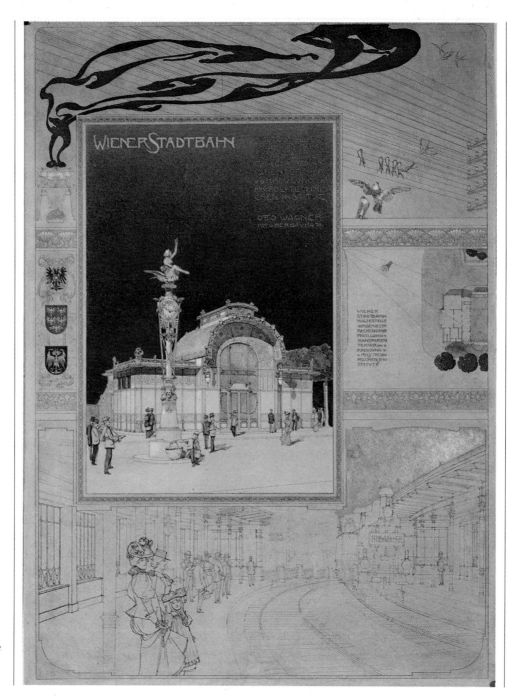

Plate 4
Otto Wagner
Presentation drawing of the
Stadtbahn station
Karlsplatz, *c.* 1898
1.74

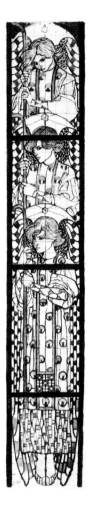

Even more far-reaching than the architectural transformation of Vienna were the political changes the city had recently undergone. The election of the Christian-Socialist Dr Karl Lueger as mayor marked a decisive break with nineteenth-century liberalism, and at first provoked the opposition of the Emperor himself. Not until the Viennese underlined their choice by taking to the streets in mass protest did he reluctantly consent to ratify Lueger's appointment, in April 1897. But Franz Joseph, master of compromise, persistent to the point of doggedness, seems to have schooled himself to tolerate even the unruly Lueger. A little-known photograph (fig. 14) gives the lie to the legend of the deep-rooted hostility between the two men: Lueger, every inch the mayor, with his chain of office, holds the centre of the stage, while the Emperor, very much in the wings, whispers confidentially in his ear.

It is worth pausing briefly to consider the character and career of Lueger, since these are so closely bound up with the fortunes of the city in which he grew to fame. The son of a minor civil servant of limited education, Lueger has sometimes

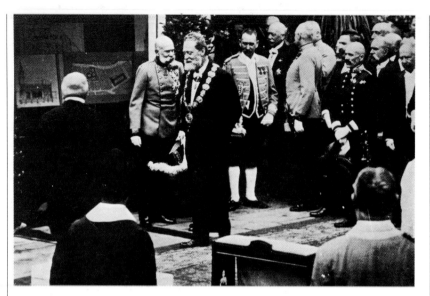

been seen as a cynical demagogue who
jumped on the already-moving
bandwagon of anti-Semitism, allying
himself (when it suited him) with the
radical German nationalist party. And yet
his famous dictum 'It is I who decide who's
a Jew' bespeaks not only a profound
contempt for his fellow men, but at the
same time an intense pragmatism. For
Lueger knew that Vienna's extensive
programme of public building works, the
bringing of gas and electricity and street
lighting and better communications to
larger and larger areas of the city, could not
be achieved without Jewish expertise,
Jewish entrepreneurial skills (though the
money was also raised partly by the large
scale public issue of bonds and shares),
above all, Jewish capital. By the time of
Lueger's death in 1910, Vienna, though
still 'somewhat smaller than the rest of the
world's great cities', had been transformed
into a modern metropolis; and when he
died, the Viennese flocked on to the streets
in their thousands to pay final tribute to the
man they themselves dubbed 'der schöne
Karl'.

Not only the city, but the empire too
was changing. The empire in fact was
exploding from within, being torn apart
by centrifugal forces beyond the power of
any individual or institution to control. In
a curious way, the only thing that held the
whole ramshackle affair together was the
Emperor himself, whose myriad subjects
owed no other allegiance save to their
native homelands with their different
languages and cultures. Throughout the
whole of his reign, Franz Joseph had had to
live with the intractable problems posed by
the various nationalities that made up his
sprawling, polyglot empire, whose
increasingly vociferous demands for self
determination and equal rights could no
longer be ignored or shouted down. The
only other unifying factor was the army,
which likewise owed allegiance to the
person of the Emperor rather than to any
dynastic or political or even strategic ideal.
But the army, like the empire, was a
polyglot affair where the loyal oath could
be taken in any one of a dozen languages,
and in which all the different regiments had
in common only about fifty words of
German, encompassing the most basic
commands such as fire, or advance, or
stand your ground, or run away. Better
equipped for the ballroom and the parade
ground than for fighting the great
European war some dreaded and which
many anticipated with ill-disguised glee, in
1918 Franz Joseph's beloved army
vanished like a puff of smoke, as the
regiments returned home and Austria was
stripped of her far-flung provinces.

Meanwhile, Vienna danced. Even

today, balls and festivities are part of the Viennese way of life; in the early 1900s, they were, at least for the uppermost social strata, one of the fundamental proofs of existence. Polite society waltzed, not least to take its mind off anything remotely serious. Again, it is sometimes the smallest objects that evoke most vividly this bygone age: not the elaborate dresses and ball gowns, but a lady's favour, carried by an unknown hand, at the Ball of the City of Vienna in 1909. The ball organized by the city itself always managed to provide a theme appropriate to the particular year, some anniversary or other event. In 1897 it was the centenary of Franz Schubert's birth, and a number of contemporary artists—Moser, Lenz, Roller and others—provided illustrations to some of Schubert's Lieder. 1909 marked the centenary of the French invasion, and again, the city provided the ladies with a beautifully bound volume of colour lithographs to accompany the card bearing the printed order of the various dances—lithographs by Geyling depicting the siege of Vienna and eventual defeat of Napoleon's armies.

Polite society, of course, accounted for only a small percentage of Vienna's population. Well into the twentieth century, the Austrian capital still exhibited the most glaring social contrasts. Grinding, barefoot poverty was something visible and tangible, at least in the outlying districts, though it had been largely banished from the city centre. As late as 1923, the painter Anton Faistauer could still write of the 'shallow, light-minded exuberance of the inner city, the moneyed Jewish bourgeoisie', comparing this with the 'tragic faces, the hunger and the hatred' of the suburbs. For many, prostitution was still an accepted way of life. Whereas for some of Franz Joseph's subjects life was an endless succession of balls and excursions and hunting parties and social engagements, others were so poor they did not even have a bed to sleep in. The situation was made worse by the acute housing shortage, occasioned by the massive drift to the city in the last decades of the nineteenth century. Vienna was simply over-populated. If the empire threatened to explode as a result of the pent-up demands of its various national minorities, the city was bursting at the seams from sheer pressure of numbers.

The lower classes of course did not go to balls or receptions. They had their own equally colourful entertainments. While the ladies and gentlemen of the Court went riding in the Prater, the huge park to the east of the city, the common folk concentrated down the other end of the park in what was known as the Wurstelprater or 'sausage Prater', a kind of sprawling fun-fair with sideshows and fairground booths and hot-dog stalls and every variety of gaudy spectacle. For the middle classes, on the other hand, the natural—one might almost say inevitable meeting-place was the coffee house, that uniquely Viennese institution which has no real counterpart in any other city, but which played a role in some ways comparable to that of a gentlemen's club (fig. 15). It was a place of refuge from the family and the telephone, where messages could be left and letters kept. You could sit all day over a single cup of coffee, and nobody thought the worse of you. After only a couple of visits, the waiter would

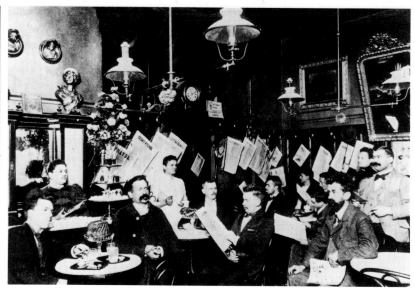

Figure 15
Viennese coffee house
*c.*1900

Leutnant Gustl, managed to combine quite successfully the careers of doctor and writer).

Even after the lapse of more than eighty years, we can perhaps capture something of the mood of those who thronged Vienna's coffee houses as the old century gave way to the new, a sense of bewilderment and excitement at the dawn of what many hailed as a 'new age', in which some thought the arts and sciences would lead humanity towards a happier and more enlightened future. Yet the optimists were in the minority. Had we been party to some of these coffee-house discussions, we might also have been conscious of an air of deep foreboding and, at the same time, a sense of frustration. Many creative artists and writers, for whom more than anyone Bahr was the mouthpiece, were oppressed by the burden of the past, the weight of tradition. Though there was freedom of thought (if not freedom of speech) they were also acutely aware that their lives were lived out beneath the dead hand of what the writer Robert Musil described as 'the best bureaucracy in Europe'. They were aware, too, of the hostility of the press, the philistinism of the wider public, a deep-rooted hostility to innovation, even to independent thought. But in Vienna, as Musil observed, genius and independent thought were considered presumptuous, since in Austria 'only geniuses were dismissed as louts and never, as happened elsewhere, louts hailed as geniuses'. And yet, Musil continued, the Austro-Hungarian empire was, despite all indications to the contrary, a land of geniuses, and it was perhaps this which brought about its downfall.

remember who you were and what paper you read. If you and your friends were 'regulars', you had a reserved table. The coffee house was not just a place of refreshment, it was a way of life.

The coffee house played an important role in the social and intellectual life of the city. Everyone knew who was to be found in which establishment, and at what hour. There were literary coffee houses and financial coffee houses and journalists' coffee houses and political coffee houses. Liveliest were the literary coffee houses like the long-vanished Cafe Griensteidl. Here, figures such as the essayist Hermann Bahr or the poet Peter Altenberg were to be found engaged in earnest debate, or simply holding court. It seemed there was time for every subject under the sun, subjects as diverse as the revolt against naturalism in literature and the latest discoveries of medical science (although Arthur Schnitzler, who in 1900 created a stir with his 'psychological' short story

1.1 Georg Zala
*Emperor Franz Joseph I, c.*1908
Marble
Height 93 cm
Heeresgeschichtliches Museum, Vienna
(Inv. No. B.I. 19.031)

1.2 Oval table with carved floral
decoration, part of a suite of furniture
previously belonging to the apartments of
the Archduchess Gisela at Schönbrunn
Palace
77 × 100 × 70 cm
Bundesmobilienverwaltung, Vienna (Inv.
No. S 24 176)

1.3 Franz Matsch
Katharina Schratt, 1898
Oil
84.5 × 56.8 cm
Theatersammlung der Oesterreichischen
Nationalbibliothek, Vienna (Inv. No.
0-119)
An actress at Vienna's Burgtheater,
Katharina Schratt remained the Emperor's
only intimate female companion after the
death of the Empress Elisabeth in 1898.

1.4 Imperial Jubilee 1898
Group of medals and plaquettes
commemorating the Imperial Jubilee of
1898, etc.

a. Anon
Plaquette commemorating the Imperial
Jubilee, with two portraits of Franz
Joseph, as he appeared as a young man in
1848, and in 1898
Brass
34 × 34 mm

b. Anton Scharff
Medal inscribed 'Grateful Vienna',
commemorating the Imperial Jubilee,
with a view of the Ringstrasse and
Heldenplatz
Bronze
60 mm

c. Joseph Tautenhayn
Plaquette struck for the Ball of the City of
Vienna, 1898, commemorating the
Imperial Jubilee, with two portraits of
Franz Joseph, as he appeared as a young
man in 1848, and in 1898
Bronze
40 × 100 mm

d. Stefan Schwartz
Medal commemorating the death of the
Empress Elisabeth on 10 September 1898,
inscribed
ELISABETHA / IMP. AUSTRIA / REG. UNG.
Bronze
40 mm

e. Anon.
Medal issued on the occasion of the
Imperial Jubilee by the Austrian Social
Democratic Party, commemorating the
freedom fighters of 1848
Bronze
50 mm

f. Johann Schwerdtner
Plaquette commemorating the opening of
the Vienna Chamber of Commerce, 1903
Silver
47 × 35 mm

g. Franz Xaver Pawlik
Plaquette, with an allegory of Vienna's
fresh water supply
('Hochquellenleitung'), in the
background a view of the city with St
Stephen's cathedral and the Kahlenberg,
1906
Bronze
60 × 85 mm
Heeresgeschichtliches Museum, Vienna

1.5 Imperial Jubilee 1908
Group of medals and plaquettes
commemorating the Imperial Jubilee of
1908, etc.

a. Heinrich Kautsch
Plaquette, with an allegory of sculpture,
depicting the tribute of the arts on the
occasion of the Imperial Jubilee, inscribed
BILDHAUEREI
Zinc
55 × 85 mm

b. Anon.
Plaquette, with a portrait head of the
Emperor, and three allegorical figures,
commemorating the Imperial Jubilee,
inscribed
FRANZ JOSEF I / VIRIBUS UNITIS /
= 1848 = 1908 =
Bronze
87 × 65 mm

c. Rudolf Marschall
Plaquette commemorating the Imperial
Jubilee, with a portrait bust of the
Emperor
Bronze
93 × 64 mm

d. Ludwig Hujer
Plaquette issued by the Vienna
Numismatic Society to commemorate the
Imperial Jubilee
Bronze
80 × 50 mm

e. P. Schulz
Plaquette celebrating New Year 1908
Silver gilt
58 × 58 mm

f. Anon.
Medal struck to commemorate the
shooting competition held to mark the
Emperor's 80th birthday on 18 August
1910
Bronze
70 mm

g. Alfred Hofmann
Octagonal plaquette struck to
commemorate the First International
Exhibition devoted to Field Sports (*1.
Internationale Jagdausstellung*), Vienna 1910
Silver
60 × 60 mm

h. Hans Schaefer
Plaquette depicting the visit of the
Emperor to the First International
Exhibition devoted to Field Sports (*1.
Internationale Jagdausstellung*), Vienna 1910
Bronze
60 × 80 mm

i. Alfred Hofmann
Medal depicting an Austrian 10-Kronen
stamp, struck to commemorate the
International Postage Stamp Exhibition,
Vienna 1911
Silver
45 mm
Heeresgeschichtliches Museum, Vienna

1.6 *Viribus Unitis. Das Buch vom Kaiser*
With an introduction by Dr. Josef Alexander
Freiherr von Helfert
Budapest - Vienna - Leipzig, 1898
Heeresgeschichtliches Museum, Vienna

1.7 *Huldigungsadresse der österreichischen
Israeliten,* 1908
Loyal address, written on parchment,
contained in a silver cassette borne on a
wooden stand with silver inset
Height 31 cm
Kunsthistorisches Museum, Vienna,
Museum Oesterreichischer Kultur (Inv.
No. TM 14)
Presented to the Emperor Franz Joseph on
the occasion of the Imperial Jubilee 1908 by
the Israelite community of the
Austro-Hungarian monarchy.

1.8 *60 Jahre auf Habsburgs Throne. Festgabe
zum 60-jährigen Regierungsjubiläum Sr.
Majestät Kaiser Franz Joseph I*
By Johannes Emmer
Vienna, 1908
2 volumes
Peter Vergo
One of the many publications celebrating
the sixtieth anniversary of Emperor Franz
Joseph's accession to the throne.

1.9 Ernst Graner
The Emperor leaving the Hofburg
Watercolour
36.5 × 47.5 cm
Heeresgeschichtliches Museum, Vienna
(Inv. No. B.I. 32.469)

1.10 Emperor Franz Joseph and Kaiser
Wilhelm of Germany in an open carriage
Photograph
Bildarchiv der Oesterreichischen
Nationalbibliothek, Vienna

1.11 *Emperor Franz Joseph receiving the
German princes at Schloss Schönbrunn, 7 May
1908*
Coloured autotype after the oil painting by
Franz Matsch
30.7 × 42.2 cm
Heeresgeschichtliches Museum, Vienna
(Inv. No. B.I. 29.086)

1.12 *Dinner in honour of King Edward VII's
visit to Bad Ischl, 15 August 1907*
Heliogravure after the painting by Theo
Zasche
32.6 × 43.6 cm
Heeresgeschichtliches Museum, Vienna
(Inv. No. B.I. 19.046)

1.13 Felician von Myrbach
*Standard bearer of a Hungarian Infantry
Regiment*
Watercolour
31.2 × 18.6 cm
Heeresgeschichtliches Museum, Vienna
(Inv. No. E.B. 1982-65)

1.14 Felician von Myrbach
Open-air mass
Watercolour
11.5 × 21.3 cm
Heeresgeschichtliches Museum, Vienna
(Inv. No. B.I. 28.367)

1.15 *Die österreich.-ungarische Armee*
By Hauptmann Anton Sussmann
Leipzig, n.d. (*c.*1905)
National Army Museum, London

1.16 Uniform
Officer's full-dress uniform, worn by HRH
The Duke of Connaught as
Colonel-in-Chief of the 4th Hussars,
consisting of shako with plume, full-dress
tunic, pelisse, pantaloons, pouch belt and
pouch, waistbelt with sword slings, hessian
boots with spurs
*c.*1910
National Army Museum, London (Inv. No.
6001-4-1:13)

1.17 Silver trumpet
Carried by the 6th Uhlan Regiment at the
Imperial Jubilee celebrations of June 1908
Heeresgeschichtliches Museum, Vienna
(Inv. No. N.I. 70.650)

1.18 Rudolf von Alt
Makart's Studio, 1895
Watercolour
69.5 × 100.4 cm
Historisches Museum der Stadt Wien

1.19 Hans Makart
The Death of Siegfried, 1866-8
Oil
81.5 × 63 cm
Creditanstalt-Bankverein, Vienna

1.20 Anton Romako
Singing Girl (Lily von Korn), 1887
Watercolour
30 × 23 cm
Collection Ranuccio Bianchi Bandinelli

1.21 Gustav Klimt
Altar of Dionysos, 1886
Oil sketch for a lunette for Vienna's
Burgtheater
29.5 × 156 cm
Creditanstalt-Bankverein, Vienna

1.22 Adolf Boehm
'Ade'
Brush and ink
32 × 21.1 cm
Historisches Museum der Stadt Wien (Inv.
No. 10383)

1.23 Heinrich Lefler
'Sah ein Knab' ein Röslein stehn'
Brush and ink
19.4 × 26.5 cm
Historisches Museum der Stadt Wien (Inv.
No. 10375)

1.24 Maximilian Lenz
'Erlkönig'
Pencil, brush and ink
12.1 × 29.4 cm
Historisches Museum der Stadt Wien (Inv.
No. 10373)

1.25 Koloman (Kolo) Moser
'Lockte mich ein Irrlicht hin'
Brush and ink
32.3 × 23 cm
Historisches Museum der Stadt Wien (Inv. No. 10380)

1.26 Alfred Roller
'Guten Morgen, schöne Müllerin'
Brush and ink
11.7 × 20.2 cm
Historisches Museum der Stadt Wien (Inv. No. 10377)

1.27 Ladies' favour
Produced for the Ball of the City of Vienna, 1909
Volume bound in white leather, containing 14 colour lithographs by Remigius Geyling, in carrying case
16 × 18.5 cm
Dr. Wilhelm Schlag, Vienna

1.28 Evening gown
*c.*1900
White silk
Historisches Museum der Stadt Wien (Inv. No. M.11.079/2)

1.29 August Eisenmenger
Johann Strauss the Younger, 1887–8
Oil
100 × 74 cm
Historisches Museum der Stadt Wien (Inv. No. 76.092)
Copy.

1.30 Koloman (Kolo) Moser
Music, c. 1896
No. 37 of Gerlach's *Allegorien*
35 × 44 cm
Historisches Museum der Stadt Wien

1.31 Koloman (Kolo) Moser
Song, Love, Music, Dance, c. 1895
No. 28 of Gerlach's *Allegorien*
25.9 × 26.2 cm
Historisches Museum der Stadt Wien

1.32 Heinrich Lefler
Song, Music, Dance, Wine, c. 1895
Drawing for No. 32 of Gerlach's *Allegorien*
Brush, pen and ink
46 × 36.5 cm
Historisches Museum der Stadt Wien

1.33 Karl Feiertag
In the Wurstelprater
Watercolour and pencil
18 × 28 cm
Historisches Museum der Stadt Wien

1.34 Karl Feiertag
Kasperltheater in the Prater
Watercolour and pencil
18 × 28 cm
Historisches Museum der Stadt Wien

1.35 Rudolf von Alt
View of Vienna with the Spanish Riding School, 1895
Watercolour
14.8 × 20.2 cm
Viktor Fogarassy, Graz

1.36 Maximilian Lenz
Sirk-Ecke, 1900
Oil
71 × 162 cm
Historisches Museum der Stadt Wien (Inv. No. 18 628)
The painting shows the intersection of the Ringstrasse and Kärntnerstrasse, with the Opera House in the background. At the turn of the century, this was a place where the Viennese would stroll, meet and gossip.

1.37 Vienna, the Naschmarkt
Photograph, *c.*1910
Bildarchiv der Oesterreichischen Nationalbibliothek, Vienna
Even today, the Naschmarkt is Vienna's principal street market. In the early 1900s, growers would set up stalls and sell produce brought in from the surrounding countryside.

1.38 Otto Friedrich
The Josefsplatz, 1908
Colour lithograph
28 × 32.7 cm
Nicolas Powell, Bristol

1.39 Carl Moll
Vienna, Naschmarkt and Karlskirche, 1894
Oil
56 × 83 cm
Neue Galerie der Stadt Linz, Wolfgang Gurlitt Museum (Inv. No. 187)
The Karlskirche (church of St Charles Borromeo, built 1716-39) is one of the architectural landmarks of Vienna and, apart from St Stephen's cathedral, the city's most important church. Gustav Mahler was married there in March 1902.

1.40 Franz Poledne
The Cafe Griensteidl, 1897
Watercolour
35 × 44 cm
Historisches Museum der Stadt Wien

1.41 Photograph showing the interior of the Cafe Griensteidl, *c.*1897
Historisches Museum der Stadt Wien
In the 1890s, the Cafe Griensteidl was one of Vienna's most celebrated literary coffee houses. This photograph was originally published by the society weekly *Die vornehme Welt*; see also cat. no. **1.**40.

1.42 Emil Orlik
Peter Altenberg
Lithograph
28.5 × 12.5 cm
Ostdeutsche Galerie, Regensburg

1.43 Remigius Geyling
Caricature of Peter Altenberg, 1902
Ink and coloured chalks
37 × 35 cm
Professor and Mrs Christian M. Nebehay, Vienna

1.44 Emil Orlik
The Writer Hermann Bahr, 1908
Etching
29.8 × 19.9 cm
Ostdeutsche Galerie, Regensburg

1.45 *Wie ich es sehe*
By Peter Altenberg
Berlin, 1904
British Library

1.46 *Leutnant Gustl*
By Arthur Schnitzler
Berlin, 1901
British Library

1.47 *Die Traumdeutung*
By Sigmund Freud
Leipzig - Vienna, 1900
British Library
Freud's *Interpretation of Dreams* was first
published in 1900 in an edition of 600 copies;
it took about 10 years to sell out.

1.48 *Geschlecht und Charakter*
By Otto Weininger
Vienna - Leipzig, 1903
British Library

1.49 Two pages from the draft of a speech
by Bürgermeister Karl Lueger on taking
office, April 1897
Stadtbibliothek, Vienna (Inv. No. 29.925)

1.50 *Kikeriki*
23 October 1904
Issue marking Bürgermeister Karl Lueger's
60th birthday
Stadtbibliothek, Vienna

1.51 Adolf Karpellus
Poster for *Julius Meinl's Sultan-Feigenkaffee,*
1899
Colour lithograph
134 × 90 cm
Oesterreichisches Museum für angewandte
Kunst, Vienna (Inv. No. P.I. 1970)
Meinl's was, and is, a well known Viennese
brand of coffee.

1.52 Julius Klinger
Poster for the Third International Motor
Show, 1903
Colour lithograph
120 × 91.8 cm
Oesterreichisches Museum für angewandte
Kunst, Vienna (Inv. No. P.I. 2061)

1.53 Hans Kalmsteiner
Poster for the First International Exhibition
devoted to Field Sports, 1910
Colour lithograph
85.7 × 62.9 cm
Fischer Fine Art Ltd., London
Text reads: Under the Royal Patronage of
His Imperial and Royal Apostolic Majesty
Emperor Franz Joseph I. The First
International Exhibition of Hunting, May
1910, Vienna. (In Russian)

1.54 *1. Internationale Jagdausstellung, Wien*
1910
Album commemorating the First
International Exhibition devoted to Field
Sports held in Vienna, 1910
Vienna & Leipzig, 1912
Dr. Wilhelm Schlag, Vienna

1.55 City of Vienna
Municipal Bond to the value of 200 Kronen,
1898
Creditanstalt-Bankverein, Vienna

1.56 Kaiserjubiläum-Stadttheater
(Volksoper)
Bond to the value of 100 Gulden, 1898
Creditanstalt-Bankverein, Vienna

1.57 Donauregulierungskommission
(Danube Regulation Authority)
Bond to the value of 200 Kronen, 1899
Albert Beronneau, Vienna
Facsimile

1.58 Graz-Köflacher Eisenbahn- und
Bergbaugesellschaft (Graz-Köflach Railway
and Mine Construction Co.)
Bond to the value of 400 Kronen, 1902
Creditanstalt-Bankverein, Vienna

1.59 5 Kronen piece (Hungarian)
Imperial Jubilee issue, 1908
Silver
Creditanstalt-Bankverein, Vienna

1.60 1 Krone piece (Hungarian)
Imperial Jubilee issue, 1908
Silver
Creditanstalt-Bankverein, Vienna

1.61 1 Krone piece (Austrian)
Imperial Jubilee issue, 1908
Silver
Creditanstalt-Bankverein, Vienna

1.62 2 Kronen piece (Austrian)
1913
Silver
Creditanstalt-Bankverein, Vienna

1.63 20 Kronen piece
1896
Gold
Creditanstalt-Bankverein, Vienna

1.64 10 Kronen piece
Imperial Jubilee issue, 1908
Gold
Creditanstalt-Bankverein, Vienna

1.65 Koloman (Kolo) Moser
Three designs for banknotes
Mixed media
Each design 12.5 × 18.5 cm
Oesterreichisches Museum für angewandte
Kunst, Vienna (Inv. No. K.I. 9066/1-3)

1.66 Gottlieb Theodor
Kempf-Hartenkampf
Otto Wagner, 1900
Etching
20 × 50 cm
Historisches Museum der Stadt Wien

1.67 Remigius Geyling
Otto Wagner and Karl Anton Count
Lanckoronsky
Ink and coloured chalks
49.5 × 35 cm
Professor and Mrs Christian M. Nebehay,
Vienna
Geyling's caricature shows Otto Wagner
with a model of his project for the
Stadtmuseum (City Museum), dragging
behind him the well known Viennese
collector Count Lanckoronsky, who had
publicly opposed Wagner's design.
Wagner's scheme for the building of the
museum and remodelling of the adjacent
Karlsplatz was never realized.

1.68a *Einige Skizzen, Projekte und ausgeführte Bauwerke . . .*
By Otto Wagner
Volume 1
Vienna, 1892
Victoria & Albert Museum, London

1.68b *Einige Skizzen, Projekte und ausgeführte Bauwerke . . .*
By Otto Wagner
Volume 3
Vienna, 1906
Royal Institute of British Architects

1.69 *Die Baukunst unserer Zeit*
By Otto Wagner
Vienna, 1914
Peter Vergo
Facsimile.

1.70 Otto Wagner
Glazed cabinet and matching chair, 1898-9
Walnut, inlaid with mother-of-pearl
199 × 101 × 62.5 cm (cabinet);
84 × 69.5 × 59 cm (chair)
Victoria & Albert Museum, London (Inv. No. W13 & W14–1982)
Part of a suite of dining room furniture from Wagner's own flat in Vienna's Köstlergasse.

1.71 Otto Wagner
Design for the regulation of the Danube, view of the Stubenviertel, 1897
Pencil, ink and watercolour
17.5 × 14 cm
Historisches Museum der Stadt Wien

1.72 Friedrich Ohmann
Prospect showing the regulation of the river Wien, view upstream from the Stadtpark
Pen and ink
75.5 × 124 cm
Historisches Museum der Stadt Wien (Inv. No. 106929)

1.73 Otto Wagner
Presentation drawing for the Stadtbahn (Metropolitan Railway) station Westbahnhof
Pencil, pen and ink, wash and white heightening
44.7 × 60.5 cm
Historisches Museum der Stadt Wien
This studio drawing, though reflecting Wagner's conception, seems to have been executed by Joseph Maria Olbrich, one of Wagner's assistants at the time of the Stadtbahn project.

1.74 Otto Wagner
Presentation drawing of the Stadtbahn (Metropolitan Railway) station Karlsplatz, *c.*1898
Pencil, pen and ink and watercolour
64 × 45 cm
Historisches Museum der Stadt Wien

1.75 Otto Wagner
Model for a projected Academy of Fine Arts, 1898
Wood and metal
Height 74 cm
Historisches Museum der Stadt Wien

1.76 Otto Wagner
Presentation drawing for the church of St Leopold 'am Steinhof', *c.*1904
Watercolour, pen and ink
55.5 × 48 cm
Historisches Museum der Stadt Wien
Wagner built the church of St Leopold for the Lower Austrian Institution and Sanatorium 'am Steinhof' between 1904 and 1907. The decoration and furnishing of the church involved the collaboration of a number of other Secessionist artists, among them Kolo Moser and Remigius Geyling.

1.77 Josef Diveky
Otto Wagner's church of St Leopold 'am Steinhof'
Colour lithograph
90 × 120 mm
Oesterreichisches Museum für angewandte Kunst, Vienna
One of a series of postcards of architectural subjects, published by the Wiener Werkstätte.

1.78 Koloman (Kolo) Moser
Two drawings for stained glass windows for Otto Wagner's church of St Leopold 'am Steinhof', *c.*1905
Pencil, watercolour and white heightening

 a. 41.2 × 6.8 cm

 b. 30 × 30.2 cm

Oesterreichisches Museum für angewandte Kunst, Vienna (Inv. No. K.I. 8518/1-2)

1.79 Otto Wagner
Three items of furniture for the Vienna Postsparkasse (Post Office Savings Bank), *c.*1904
Beechwood, stained black, with aluminium fittings

 a. Stool, 47 × 42 × 42 cm

 b. Chair, 79 × 56 × 56 cm

 c. Bookcase, 138 × 120 × 36 cm

Victoria & Albert Museum, London (Inv. No. W16, W17 & W18–1982)
Designed *c.*1902 and made by the firm of Thonet after 1904: the bookcase for the manager's office, the armchair for the conference room and the stool for the public areas of the Post Office Savings Bank.

1.80 *Das k.k. Postsparkassenamt in Wien*
By Otto Wagner
Vienna, 1908
Galerie Michael Pabst, Munich – Vienna
Volume, in original binding designed by Otto Wagner, describing the Post Office Savings Bank in Vienna.

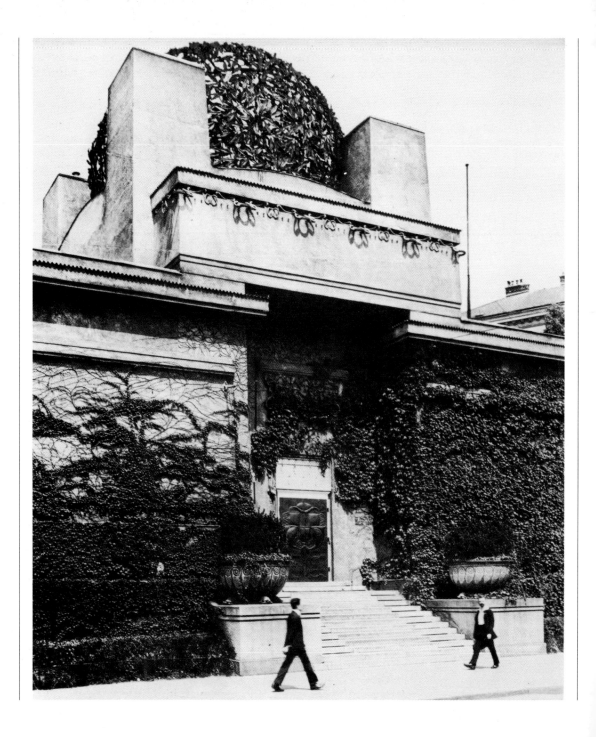

Figure 16
Vienna, the Secession
building

In April 1897, Brahms died and Karl Lueger became mayor of Vienna. In the same month, a group of younger artists led by Gustav Klimt (fig. 18) decided they could no longer tolerate the reactionary policies of Vienna's semi-official Society of Artists, and declared their intention of forming their own independent exhibiting society. Like their counterparts in Munich and Berlin who also turned their back on the art establishment of their day, these Viennese rebels gave their new society the name 'Secession'.

The Secession's aim was two-fold: to bring about a 'heightened concern' for art in Vienna, and to bring Viennese artists into 'more lively contact' with the latest development of art abroad. These aims were to be achieved through exhibitions, to which foreign artists (known as 'corresponding members' of the Secession) would contribute on a regular basis, and through the publication of the society's own magazine entitled *Ver Sacrum*—the sacred spring.

The first Secession exhibition was held in spring 1898 in the somewhat implausible surroundings of Vienna's Horticultural Society Building. At this date, the Secessionists still had no exhibition building to call their own. The society started as it meant to continue, including in this first exhibition a sizeable contingent of foreign artists, among them artists from Britain. Klimt, who had been elected the society's first president, designed the poster for the exhibition (fig. 19), and immediately fell foul of the Viennese censor, being forced to over-print his naked figure of the embattled Theseus with a somewhat contrived motif of stylized tree-trunks. It

was a bad omen. From the turn of the century onwards, nudity and the erotic element in Klimt's work provoked repeated hostility not only in official circles, but also among critics and public. Despite the unashamed prevalence of the nude in academic painting, Klimt's treatment of the theme of female nudity came under attack on numerous occasions. One of the odder criticisms of his painting *Medicine*, the second of three compositions intended to decorate the ceiling of the great hall of Vienna University, concerned the standing female figure at the upper left of the picture: if, Klimt's opponents insisted, the figure had to be female, then it should be clothed or else, if it had to be naked, then it should be male. Scornful of the prudes and philistines, Klimt inscribed his great painting *Nuda Veritas*, first shown at the fourth Vienna Secession exhibition in 1899, with a quotation from Schiller: 'If thou can'st not please all men by thine actions and by thine art, then please the few; it is bad to please the many.'

But apart from the scandals occasioned by the showing of Klimt's works, the Secession soon assumed a relatively innocuous place in the eyes of the Viennese establishment. There were official appointments and professorships at the School of Applied Arts for some of the society's leading members, though not for Klimt. Even the Emperor deigned to visit the Secession's first exhibition, where he was greeted by the aged watercolourist Rudolf von Alt in his capacity as honorary president of the new association (fig. 17). Franz Joseph, it seems, was somewhat nonplussed to find a deputation of 'rebel' artists headed by a man even older than himself. Moreover, the exhibition was to

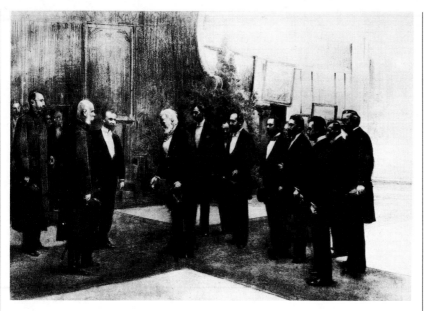

Figure 17
Rudolf Bacher
Emperor Franz Joseph received by members of the Secession,
1898
2.1

Figure 18
Gustav Klimt

everyone's surprise a great financial success, enabling the Secessionists to contemplate the realization of their dearest wish, the construction of their own exhibition building.

That the Secession was able to procure a suitable site for its new building, close to the heart of the city, was due both to the support of allies on the city council and the financial help of private backers like the wealthy Karl Wittgenstein, who was also one of Klimt's patrons. The symbolism of the site, with the Secession pointedly turning its back on the Academy of Fine Arts, was probably lost on the city fathers; but the stallholders of the Naschmarkt, Vienna's produce market which occupied the square immediately in front of the Secession building, were quick to invent their own symbolism. As they watched the most striking feature of the new edifice,

the gilded openwork dome, taking shape, they recognized in it a tribute to the greengrocers of Vienna (if not to greengrocers the world over) and dubbed it 'the Golden Cabbage'. The architect of the Secession building, Joseph Maria Olbrich, also designed the poster and catalogue cover for the society's second exhibition in November 1898, depicting the central portal of the entrance facade with the golden laurel–leaf dome rising dramatically above (pl. 5).

The Secession has become synonymous with the triumph of modern art in Vienna and at the same time one of the city's architectural landmarks (fig. 16). For this reason, we tend to forget that Olbrich put forward several alternative schemes for the new building, and that some of his earliest designs were far more traditional in character. The final design almost certainly

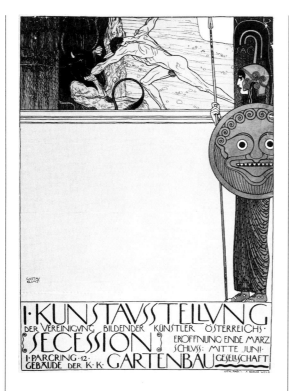

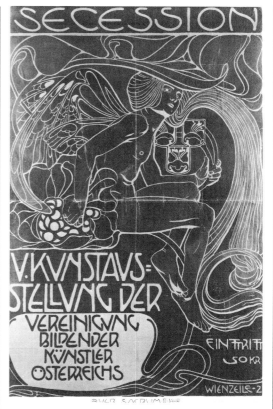

owes something to the intervention of Klimt, who made a couple of rough sketches for a small, temple-like structure with blank facades flanking the entrance, perhaps intended to carry some kind of mosaic decoration or mural paintings. The spherical laurel-leaf dome appears, however, to have been Olbrich's own invention, and remained a potent symbol for the founder members of the Secession, who presented their honorary president, Rudolf von Alt, with a sprig of gilded laurels inscribed to commemorate the dates of the society's first exhibition. Interestingly, after Alt died his daughter

gave this treasured memento to the Wittgenstein family in recognition of Karl Wittgenstein's generosity in subsidising the building of the Secession's new home.

The early Secession exhibitions were remarkably heterogeneous in character. Another aim of the association was to break down the barriers tradition had erected between different art forms, between the 'fine' and the 'applied' arts. The first exhibition had been a 'mixed' show, comprising not just paintings but also graphics, sculpture, architectural designs and objects of applied art. The Secession gave an important place to

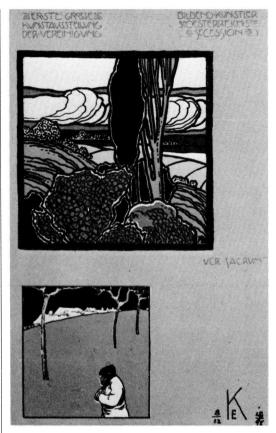

Figure 21
Adolf Boehm
Ver Sacrum postcard
2.13

Figure 22
Gustav Klimt
*Study for an Allegory of the Theatre, c.*1895
2.21

Figure 23
Gustav Klimt
Loving Couple
2.26

Figure 24
Carl Otto Czeschka
Ex Libris, 1898
2.29

Figure 25
Carl Otto Czeschka
Nude boy playing with musket,
with figure of Death behind,
1900
2.30

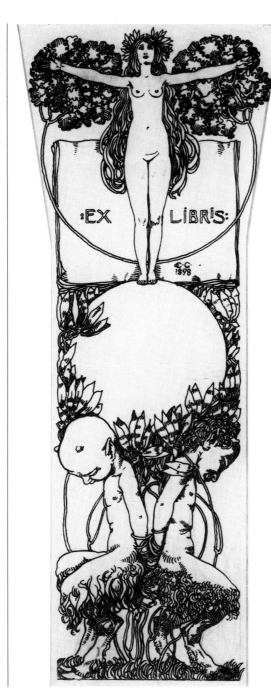

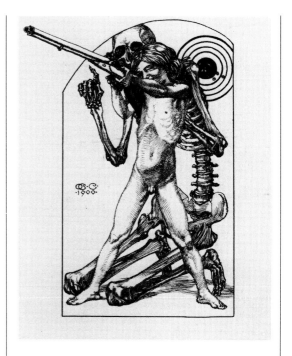

graphic art, issuing original prints as a kind of supplement to the bibliophile edition of its journal, *Ver Sacrum*. In 1899, the fifth Secession exhibition was devoted exclusively to drawings and graphics. The association also numbered among its members several gifted architects and designers, men like Josef Hoffmann and Kolo Moser who, by the force of their personality, tended to influence the content of the Secession's exhibitions. The eighth exhibition (1900), at which the work of Charles Rennie Mackintosh and his circle was first shown in Vienna, was taken up primarily with applied art and

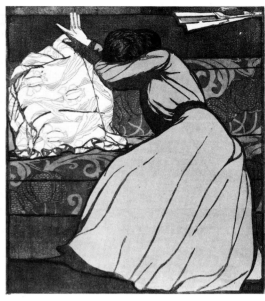

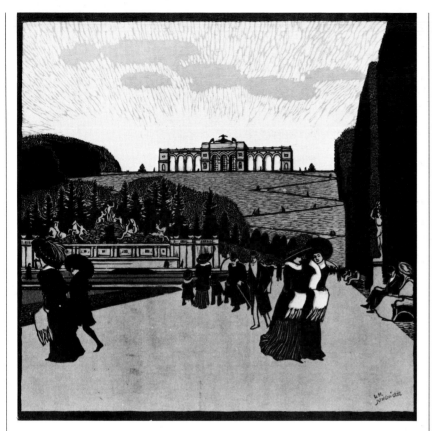

design, including work by Charles Robert Ashbee's Guild of Handicrafts and the Paris-based *La Maison Moderne* as well as by Hoffmann, Moser and the designers of the Secession.

In deliberately blurring the distinction between 'art' and 'craft', and their ambition to raise the aesthetic standard of objects of daily use, the Secessionists were heir to the same tradition as Mackintosh and the Glasgow 'school'. It is sometimes forgotten that the writings of Ruskin and Morris, and the Arts and Crafts-inspired notion of the reciprocal permeation of art and life, exerted as great an influence on the continent as they did in Britain. 'Art' no longer meant just pictures to hang on walls. Aesthetic considerations determined the form of even the most mundane objects such as a cruet or a candlestick. The architect became his own interior designer and it was now he, in consultation with his client, who decided not only on the overall shape of a building, but on every detail of the internal arrangements, the furnishings, the fabrics,

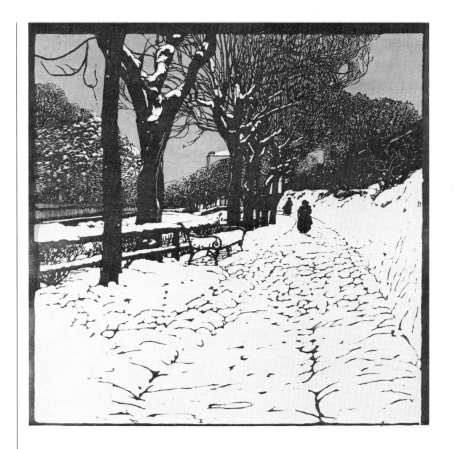

Figure 28
Carl Moll
Winter (Hohe Warte in Wien),
1903
2.36

the decor, the cutlery. In the early 1900s Hoffmann was engaged in building a colony of villas for wealthy clients on the Hohe Warte, a wooded ridge to north of Vienna where the city's bourgeoisie were beginning to retreat in search of seclusion and clean air. In these specially commissioned houses, each different, each reflecting the particular tastes and life-style of its owner, the ideal of the 'through-designed' interior could be carried to the ultimate heights of refinement. We can gain some impression of one of these interiors, designed by Hoffmann for his fellow-Secessionist, the painter Carl Moll, from Moll's own *Self portrait in his studio* (pl. 8). Occupying pride of place is a statuette by one of the 'corresponding members' of the Secession, the Belgian sculptor Georges Minne. Its prominent position in the painting is no coincidence: quite apart from the fact that Moll was especially proud of having acquired this particular piece, it was another cherished aim of the Secessionist designers to create suitable settings for the

display of works of art.

In the design of certain objects, especially furniture, purely aesthetic considerations sometimes prevailed even over practical needs. In the case of Moser's spectacular secretaire with 'disappearing' chair (pl. 9), it is interesting to compare the original drawing (fig. 32) with the piece as actually executed. Structural solidity demanded a further pair of legs in the middle of the cabinet, and they are indeed shown in the drawing, but then scratched out as an afterthought, with the result that the cabinet, splendid though it

Figure 29
Joseph Maria Olbrich
Candlestick, *c.*1901
2.39

Figure 30
Joseph Maria Olbrich
Chair, *c.*1899
2.38

Figure 31
Josef Hoffmann
Chair, 1901
2.40

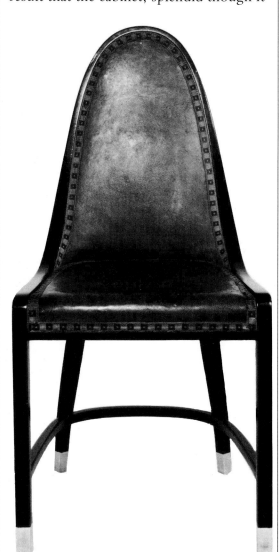

Figure 32
Kolo Moser
Furniture design for 'lady's
writing desk'
2.48a

Figure 33
Kolo Moser
Furniture design for 'two
large armchairs'
2.48b

is, remains unsupported in the centre and in danger of collapsing. Curiously, lack of concern for structural considerations is another characteristic the Austrian designers shared with Mackintosh, whose furniture displays on occasion a sublime disregard for practicalities, so that his

elegant, attenuated chairs, for example, have been known to succumb to the stresses and strains of actual use. Hoffmann, Moser and their contemporaries advocated a return to 'genuine' craftsmanship, a respect for the characteristics of the materials employed,

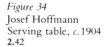

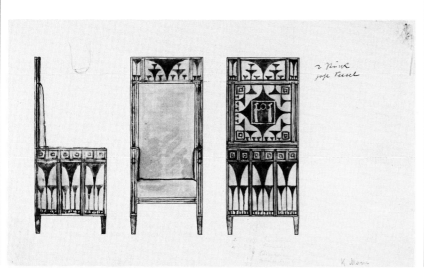

Figure 34
Josef Hoffmann
Serving table, *c.*1904
2.42

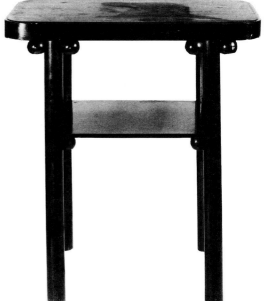

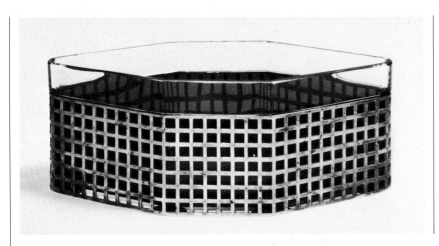

and for considerations such as utility and ease of use; but a design like Moser's pendant lamp (fig. 32) has little to do with either reason or utility. Rather, it is an impressive piece of fantasy, a glittering cascade of metal strips and turned glass droplets that must have been as impossible to live with as it is magnificent to look at.

Figure 35
Josef Hoffmann
Metal basket with glass
liner, 1905
2.43

Figure 36
Josef Hoffmann
Fruit basket, *c.*1904
2.45

Figure 37
Kolo Moser
Pendant lamp
2.46

Figure 38
Kolo Moser
Pendant lamp: detail of
stamps
2.46

Figure 39
Kolo Moser
Four glasses, *c.*1899
2.47

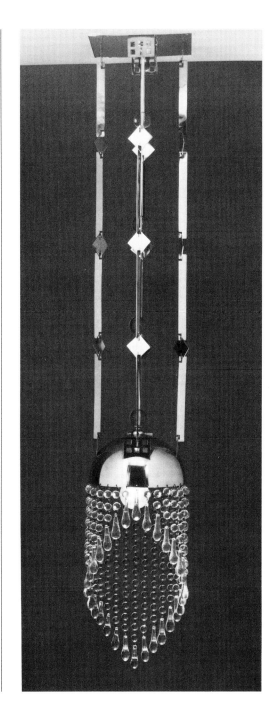

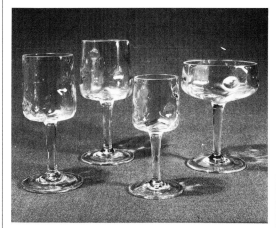

Figure 40
Josef Hoffmann
Three-fold screen, *c.*1899
2.41

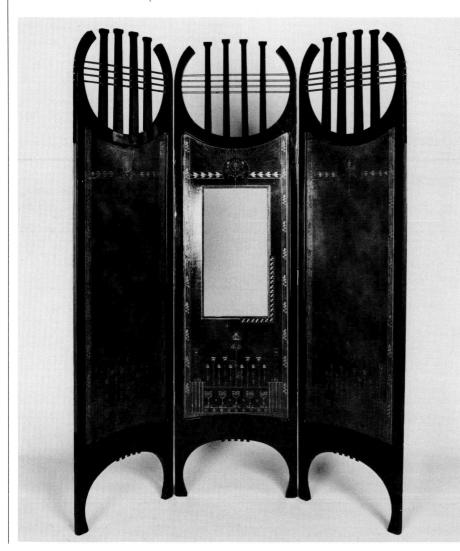

2.1 Rudolf Bacher
Emperor Franz Joseph received by members of the Vienna Secession, 1898
Pencil
34.7 × 45.8 cm
Historisches Museum der Stadt Wien
The interior depicted by Bacher is not that of Olbrich's Secession building, but the temporary exhibition space of the Viennese Horticultural Society building, where the first Secession exhibition was held in the spring of 1898.

2.2 Joseph Maria Olbrich
Four drawings for the Vienna Secession building, 1898

 a. Watercolour, gold paint, pencil, pen and ink
 11.1 × 21.1 cm

 b. Pencil
 12 × 18.9 cm

 c. Pencil, pen and ink and gold heightening
 6.2 × 8.1 cm

 d. Pencil, pen and ink
 4.8 × 5.4 cm

Kunstbibliothek, Berlin (Inv. No. Hdz 10084, 10085, 10082, 10083)

2.3 Gilded laurel leaves, in frame, presented to Rudolf von Alt by the founder members of the Vienna Secession, 1898. With an inscription '1898, März – Juni'
26 × 17 cm
Private collection
The celebrated watercolourist Rudolf von Alt was honorary president of the Secession. The gilded laurels recall the dome of Olbrich's Secession building.

2.4a Gustav Klimt
Poster for the first Vienna Secession exhibition, 1898
Colour lithograph
63.5 × 46.3 cm
Oesterreichisches Museum für angewandte Kunst, Vienna (Inv. No. P.I. 1657a)

2.4b **Gustav Klimt**
Poster for the first Vienna Secession
exhibition, 1898
Colour lithograph
63.5 × 46.3 cm
Oesterreichisches Museum für angewandte
Kunst, Vienna (Inv. No. P.I. 1657b)
After censorship.

2.5 **Joseph Maria Olbrich**
Poster for the second Vienna Secession
exhibition, 1898
Colour lithograph
73.6 × 31.8 cm
Fischer Fine Art Ltd., London

2.6 **Alfred Roller**
Poster for the fourth Vienna Secession
exhibition, 1899
Colour lithograph
54 × 72.5 cm
Victoria & Albert Museum, London (Inv.
No. E3319 - 1932)

2.7 **Koloman (Kolo) Moser**
Poster for the fifth Vienna Secession
exhibition, 1899
Colour lithograph
99 × 69.2 cm
Fischer Fine Art Ltd., London
Red version.

2.8 **Adolf Boehm**
Poster for the eighth Vienna Secession
exhibition, 1900
Colour lithograph
95 × 63 cm
Historisches Museum der Stadt Wien (Inv.
No. 129055)

2.9 **Johann Viktor Krämer**
Poster for the eleventh Vienna Secession
exhibition, 1901
Colour lithograph
50 × 39 cm
Fischer Fine Art Ltd., London

2.10 **Ferdinand Andri**
Poster for the twenty-sixth Vienna
Secession exhibition, 1906
Colour lithograph
95 × 63 cm
Oesterreichisches Museum für angewandte
Kunst, Vienna (Inv. No. P.I. 2666)

2.11 Catalogue of first Vienna Secession
exhibition, 1898
Stadtbibliothek, Vienna (Inv. No. 40.089A)

2.12 *Ver Sacrum*
Volume I (1898), No. 3
Liverpool Public Library

2.13 Four postcards
Inscribed 'Ver Sacrum, 1. Jahr', 1898
Colour lithographs
Each 13.9 × 9 cm
Galerie Michael Pabst, Munich - Vienna

2.14 **Koloman (Kolo) Moser**
Girl (*Ver Sacrum*, Beilage zur
Gründerausgabe, Heft 7), 1898
Colour lithograph
20.5 × 19.5 cm
Victoria & Albert Museum, London (Inv.
No. Circ. 110-1971)
This print appeared as a supplement to the
bibliophile edition of *Ver Sacrum*, the journal
of the Vienna Secession.

2.15 **Wilhelm List**
Tristan (design for *Ver Sacrum*), 1899
Colour lithograph
55 × 49.5 cm
Victoria & Albert Museum, London (Inv.
No. Circ. 109-1971)

2.16 Portrait photograph of Gustav
Klimt, *c.*1880
Georg Eisler, Vienna

2.17 **Emil Orlik**
Gustav Klimt, 1910
Black chalk
25.7 × 15.1 cm
Ostdeutsche Galerie, Regensburg (Inv. No.
OE 695)

2.18 **Emil Orlik**
Model from Klimt's studio, 1910
Black chalk
15.2 × 15.7 cm
Ostdeutsche Galerie, Regensburg (Inv. No.
OE 697)

2.19 **Gustav Klimt**
Nuda Veritas, 1899
Oil
259 × 65 cm
Theatersammlung der Oesterreichischen
Nationalbibliothek, Vienna (Inv. No.
0-3656)
The painting once belonged to Hermann
Bahr, the writer and champion of Klimt and
the Secession.

2.20 **Gustav Klimt**
Birch Wood, 1903
Oil
110 × 110 cm
Oesterreichische Galerie, Vienna (Inv. No.
4283)
Since it was first exhibited at the eighteenth
Vienna Secession Exhibition in 1903, this
picture has been known both as *Beech Wood*
and as *Birch Wood*; the appearance of the tree
trunks makes the latter title seem more
appropriate.

2.21 **Gustav Klimt**
*Study for an Allegory of the Theatre, c.*1895
Pencil and ink
44 × 30 cm
Piccadilly Gallery, London

2.22 **Gustav Klimt**
Sketch for facade of Vienna Secession
building, 1897
Pencil
9.5 × 13.5 cm
Professor and Mrs Christian M. Nebehay,
Vienna

2.23 Remigius Geyling
Gustav Klimt at work on 'Philosophy', c.1900
Ink and coloured chalks
49 × 35.5 cm
Professor and Mrs Christian M. Nebehay,
Vienna
Philosophy, the first of three paintings done
for the great hall of Vienna University, was
first shown at the seventh Secession
exhibition in 1900, when it occasioned a
storm of public and critical protest; see also
cat. no. **2.24**.

2.24 Gustav Klimt
Study for the figure of Hygeia, 1898
Conté crayon
45.5 × 31.3 cm
Victoria & Albert Museum, London (Inv.
No. E2059 - 1973)
This sheet is a study for the principal figure
in Klimt's painting *Medicine*, the second of
three compositions intended to decorate the
ceiling of the great hall of Vienna
University. The paintings were never
installed, and were destroyed during the
Second World War.

2.25 Gustav Klimt
Reclining Nude
Blue crayon
36 × 55 cm
Piccadilly Gallery, London

2.26 Gustav Klimt
Loving Couple
Pencil
35.5 × 56 cm
Piccadilly Gallery, London

2.27 Gustav Klimt
Nude with raised leg
Pencil
68.7 × 51 cm
Margaret Fisher, London

2.28 Gustav Klimt
Reclining Girl with Fur Stole
Crayon
35 × 53 cm
Piccadilly Gallery, London

2.29 Carl Otto Czeschka
Ex Libris, 1898
Pen and ink
31 × 20.5 cm
Piccadilly Gallery, London

2.30 Carl Otto Czeschka
*Nude boy playing with musket, with figure of
Death behind*, 1900
Pen and ink
16 × 12.5 cm
Piccadilly Gallery, London

2.31 Rudolf Jettmar
Two reclining nudes
Pencil
30 × 47 cm
Georg Eisler, Vienna

2.32 Ludwig Heinrich Jungnickel
Schönbrunn, c.1906
Colour woodcut
43 × 43 cm
Galerie Michael Pabst, Munich - Vienna

2.33 Mela Koehler
Four fashion designs
Colour lithographs
Each 120 × 90 mm
Oesterreichisches Museum für angewandte
Kunst, Vienna
From a series of postcards of fashion designs
published by the Wiener Werkstätte.

2.34 Max Kurzweil
The Cushion
Colour woodcut
26 × 28.5 cm
British Museum (Inv. No. P&D
1920.1-31.22)

2.35 Carl Moll
Self portrait in his studio, c.1906
Oil
100 × 100 cm
Akademie der bildenden Künste, Vienna
The painting shows the artist at work in his
villa on the Hohe Warte designed by Josef
Hoffmann. In the foreground is the
sculpture *Kneeling Youth* by the Belgian
artist Georges Minne; see cat. no. **2.61**.

2.36 Carl Moll
Winter (Hohe Warte in Wien), 1903
Colour woodcut
43 × 43 cm
Galerie Michael Pabst, Munich - Vienna

2.37 Carl Moll
Farmhouse in Heiligenstadt
Colour woodcut
20.5 × 20.4 cm
Nicolas Powell, Bristol
One of a series entitled 'Beethoven houses',
executed in 1902-3, published as an album
by the Wiener Werkstätte in 1908. The
house No. 2 on the village square in
Heiligenstadt was where Beethoven spent
part of the summer of 1817; the
commemorative plaque can be seen in the
the print.

2.38 Joseph Maria Olbrich
Chair, c.1899
Softwood
91 × 46 × 48 cm
Victoria & Albert Museum, London (Inv.
No. W20 - 1982)
The chair, originally designed by Olbrich,
was executed by Josef Niedermoser in
Vienna.

2.39 Joseph Maria Olbrich
Candlestick, c.1901
Pewter
Height 36.3 cm
British Museum (Inv. No. M&LA
1980.5-16.7)
Although made in Darmstadt for a German
client, this candlestick is still characteristic of
Olbrich's early 'Secessionist' manner.

2.40 Josef Hoffmann
Chair, 1901
Beechwood, stained black, leather cover,
aluminium-covered feet
97 × 47 × 56 cm
Victoria & Albert Museum, London (Inv.
No. W26 - 1982)
Reproduced in 'The Art-Revival in Austria'
(*Studio* special number, 1906, fig. C14).

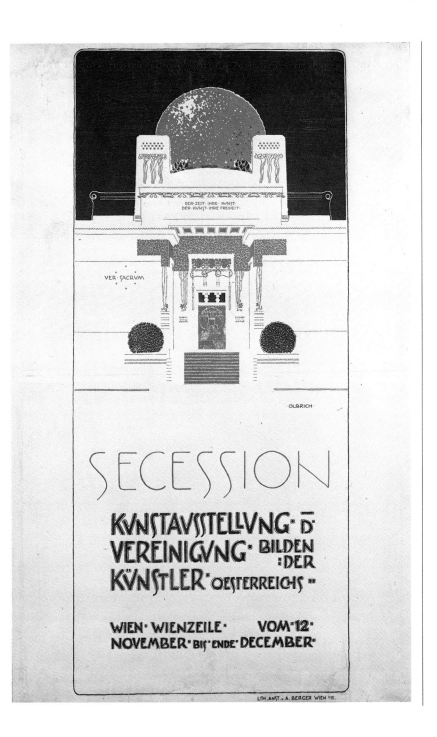

Plate 5
Joseph Maria Olbrich
Poster for the second Vienna
Secession exhibition, 1898
2.5

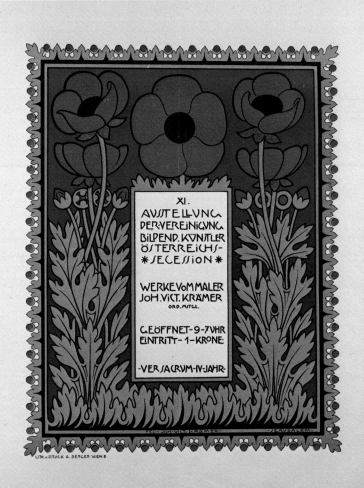

Plate 6
Johann Viktor Krämer
Poster for the eleventh
Vienna Secession
exhibition, 1901
2.9

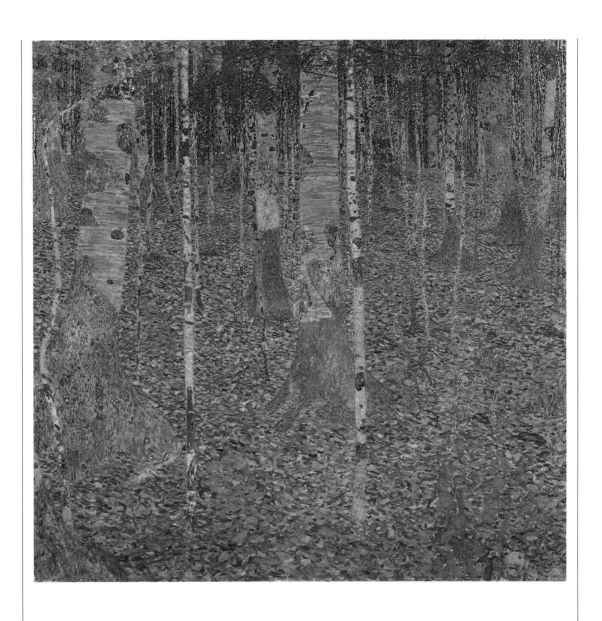

Plate 7
Gustav Klimt
Birch Wood, 1903
2.20

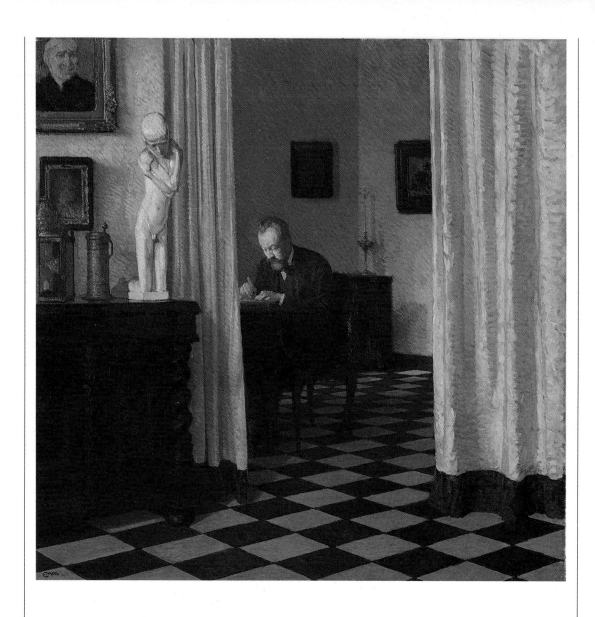

Plate 8
Carl Moll
Self portrait in his studio,
*c.*1906
2.35

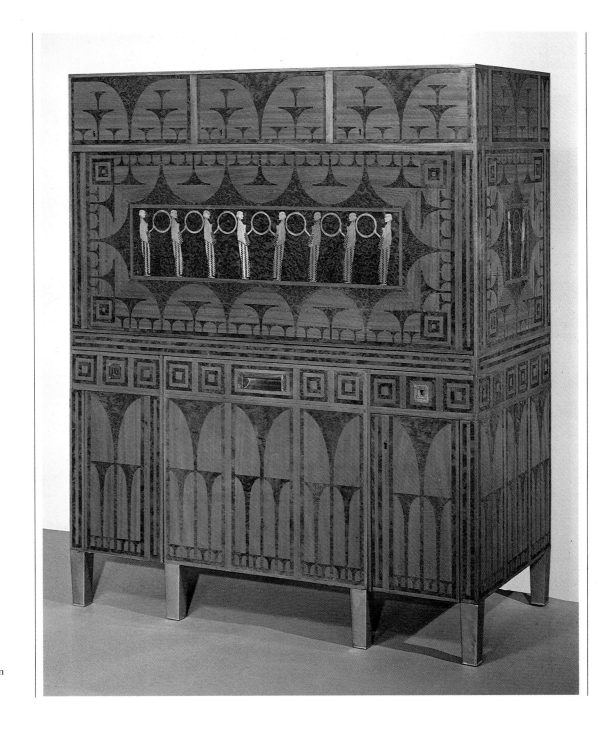

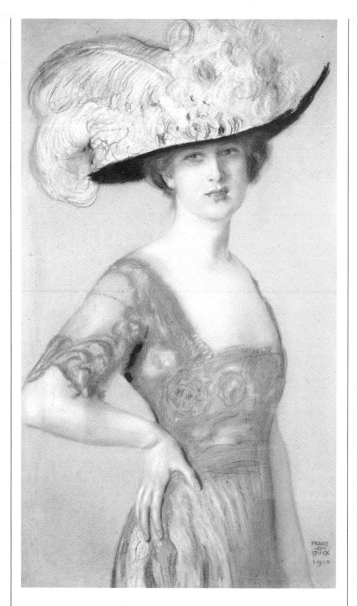

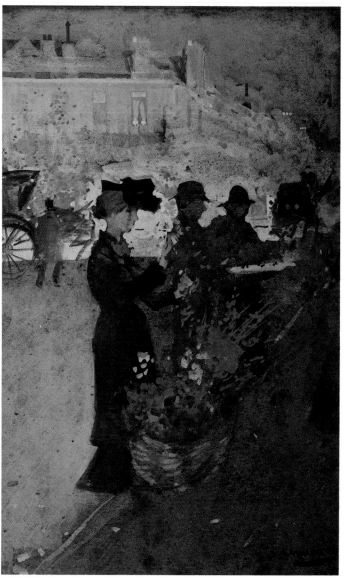

Plate 10
Franz von Stuck
The Ostrich Feather Hat, 1910
2.62

Plate 11
Edward Arthur Walton
*Flower Seller: Kensington
High Street*, 1895
2.66

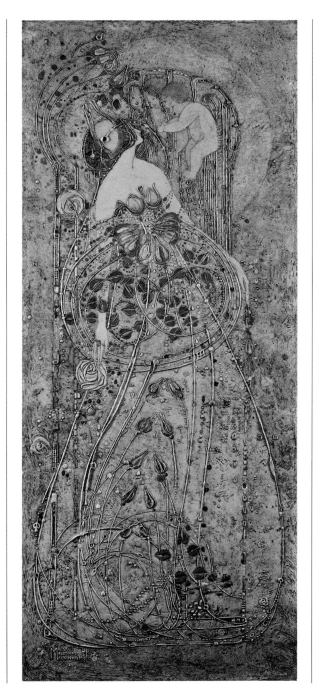

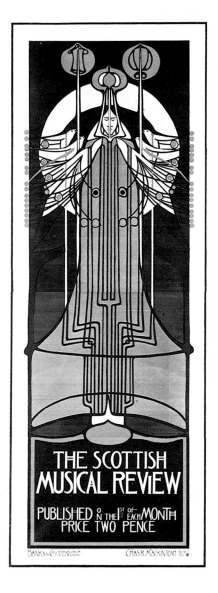

Plate 12
Margaret Macdonald
Summer, 1904
2.74

Plate 13
Charles Rennie Mackintosh
Poster for the *Scottish
Musical Review*, 1895-6
2.77

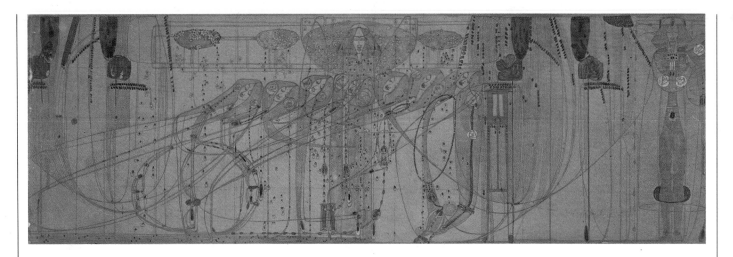

Plate 14
Margaret Macdonald
The Mysterious Garden,
*c.*1904–6
2.85

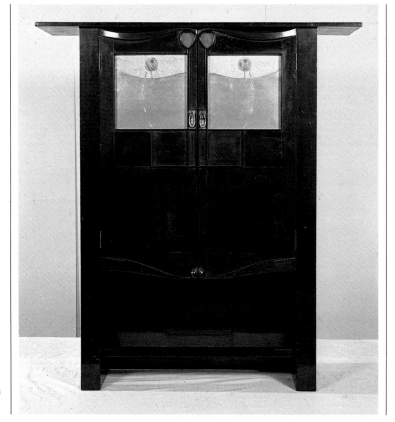

Plate 15
Charles Rennie Mackintosh
Cabinet, 1902
2.86

2.41 Josef Hoffmann
Three-fold screen, *c*.1899
Ebonized wood with inset gilt and tooled leather
Each panel 155 × 40 × 2 cm
Art Gallery and Museum, Brighton (Inv. No. 300571)
A screen of similar design but with different decoration on the panels is illustrated in the *Studio*, Vol. XVI, 1899, p. 32.

2.42 Josef Hoffmann
Serving Table, *c*.1904
Beechwood, stained black
Height 75 cm
Fischer Fine Art Ltd., London
Made by the firm of J. & J. Kohn, Vienna.

2.43 Josef Hoffmann
Metal basket with glass liner, 1905
Silver plate and crystal
6.8 × 18.5 × 8.3 cm
Victoria & Albert Museum, London (Inv. No. C30 - 1978)

2.44 Josef Hoffmann
Cruet (oil and vinegar)
Silver-plated nickel
20.5 × 13 × 8.75 cm
Victoria & Albert Museum, London (Inv. No. M9 - 1982)

2.45 Josef Hoffmann
Fruit basket, *c*.1904
Silver
27 × 23 × 23 cm
Victoria & Albert Museum, London (Inv. No. M40 - 1972)
Designed by Hoffmann and made at the Wiener Werkstätte.

2.46 Koloman (Kolo) Moser
Pendant Lamp
Cupro-nickel and glass
Height overall 108 cm
Victoria & Albert Museum, London
Stamped with the initials KM and the monogram of the Wiener Werkstätte.

2.47 Koloman (Kolo) Moser
Four glasses, *c*.1899
Art Gallery and Museum, Brighton (Inv. No. 300580-3)
Made by E. Bakalowits und Söhne, Vienna.

2.48 Koloman (Kolo) Moser
Two drawings for items from a suite of furniture, 1903

 a. for 'lady's writing desk with push in chair, exterior'

 b. for 'two large armchairs'

Pencil and watercolour
Each 21 × 34.2 cm
Oesterreichisches Museum für angewandte Kunst, Vienna (Inv. No. K.I. 12563/6-7)

2.49 Koloman (Kolo) Moser
Secretaire with push-in chair, 1903
Cedarwood, satinwood veneer and brass inlay, etched and inked
145 × 119.5 × 59.7 cm
Victoria & Albert Museum, London (Inv. No. W 8 & 8a)
Reproduced in *Die Kunst*, XII (1904), p. 340.

2.50 Koloman (Kolo) Moser
Reform dress, 1900-5
Silk
Historisches Museum der Stadt Wien (Inv. No. M 10128)

2.51 Koloman (Kolo) Moser
Female head with blossom
Ink, body colour and gold paint
23 × 23 cm
Oesterreichisches Museum für angewandte Kunst, Vienna (Inv. No. K.I. 8682/4)

Figure 41
Kolo Moser
Female head with blossom
2.51

The important role played by the participation of the 'corresponding members' of the Secession in realizing the society's aim of bringing art in Vienna into 'more lively contact with the development of art abroad' has already been touched on. It was originally the task of the painter Josef Engelhart, prior to the Secession's first exhibition in the spring of 1898, to make contact with the principal artists of the European avant-garde; to judge by his own account, he had some success in persuading them of the 'honourable, artistic intentions' of the newly founded association. And in fact, foreign artists did participate in nearly all the Secession's exhibitions held during the period 1898-1905. One can single out certain of these exhibitions as being of particular importance: the fifth, for example, which offered a broad survey of the development of contemporary European graphic art, or the sixteenth, which included a considerable number of Impressionist and Post-Impressionist paintings and enabled younger artists, Kokoschka, for example, or Gerstl, to see at first hand important work by painters such as Gauguin and van Gogh; it is not hard to detect the impact this experience had on the development of their own art.

In general, it is interesting to observe how the Secessionists themselves responded to specific foreign influences, to artists whose work they had seen at first hand in the Secession's exhibitions, or in reproduction in *Ver Sacrum* or other journals. Ashbee's furniture designs, shown at the eighth Secession exhibition in 1900 and described on that occasion by the critic Ludwig Hevesi as looking as if they came 'from a rectangular planet . . .

everything vertical, at right angles, ninety degrees', clearly had an impact on the designers of the Secession, particularly Hoffmann. The influence exerted by the Scottish artists who also showed at the same exhibition in the autumn of 1900 is discussed below.

Of all the Secessionists, however, it was Klimt who was the most eclectic in outlook, responding to an extraordinary variety of influences. There is an evident point of contact between his standing female portraits and the full length portraits painted by Whistler or by the Munich artist Franz von Stuck; both Whistler and Stuck showed at the first Vienna Secession exhibition in spring 1898. The work of the Belgian painter Fernand Khnopff significantly influenced Klimt's early landscapes; while the Beethoven frieze of 1902 and *Jurisprudence,* the third of the university paintings, first shown incomplete at the Secession in 1903, both reveal Klimt's debt to an English artist who was greatly admired in Vienna at this time: Aubrey Beardsley. Though Beardsley's work was shown only once at the Secession, at the fifth exhibition in 1899, the industrialist and patron Fritz Waerndorfer was only too happy to show his extensive collection of Beardsley's graphics to his friends, among whom he counted most of the principal Secessionists; there was also an article on Beardsley's work by the English writer Arthur Symons which appeared in the Secession's journal *Ver Sacrum* in 1903.

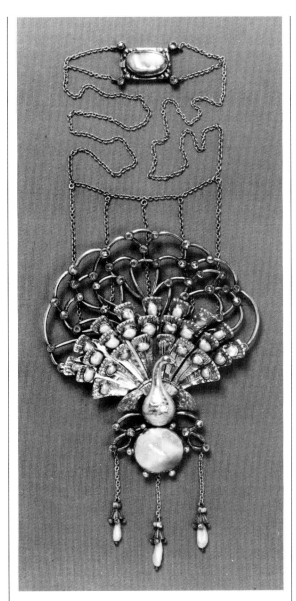

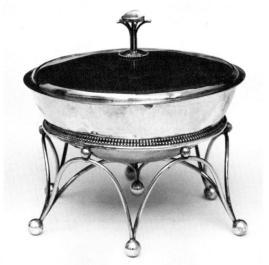

2.52 Charles Robert Ashbee
Peacock pendant brooch, *c*.1899-1900
Silver and gold, set with pearls, diamonds
and a ruby
11 × 5 cm
Victoria & Albert Museum, London
(extended loan)
Designed by Ashbee for his wife, and made
by the Guild of Handicrafts.

2.53 Charles Robert Ashbee
Chain necklace with peacock pendant, 1901
Silver and gold with pearls and diamonds
6 × 5 cm (pendant)
Victoria & Albert Museum, London (Inv.
No. M23-1965)

2.54 Charles Robert Ashbee
Bowl and cover, 1899-1900
Silver and enamel, with a stone in the finial
13 × 13 cm
Victoria & Albert Museum, London (Inv.
No. Circ. 77&77a - 1953)

2.55 Charles Robert Ashbee
Bowl and cover, 1900
Silver and enamel, set with a cabochon
10 × 25 × 11 cm
Victoria & Albert Museum, London (Inv.
No. M44&44a - 1972)

2.56 Talwin Morris
Pair of buckles, c.1900
Bronzed copper with green pastes
Each 5.5 × 5 cm
Victoria & Albert Museum, London (Inv. No. Circ. 57 & 57a - 1959)

2.57 Aubrey Beardsley
Siegfried, 1893
Indian ink and wash
40.1 × 28.7 cm
Victoria & Albert Museum, London (Inv. No. E 578 - 1932)

2.58 *Salome. Tragedy in one act . . . pictured by Aubrey Beardsley*
By Oscar Wilde
London, 1894
British Library

2.59 *Ver Sacrum*
Volume VI, 1903
Liverpool Public Library

2.60 Fernand Khnopff
Still Water, c.1890
Oil
54 × 105 cm
Kunsthistorisches Museum, Neue Galerie, Vienna (Inv. No. NG 320)
Shown at the first Vienna Secession exhibition, 1898, No. 224.

2.61 Georges Minne
Kneeling Youth
Marble
Height 79 cm
Kunsthistorisches Museum, Neue Galerie, Vienna (Inv. No. NG Pl 48)

2.62 Franz von Stuck
The Ostrich Feather Hat, 1910
Pastel
90 × 51 cm
Whitford & Hughes, London

In 1890 the Grosvenor Gallery in London held an exhibition at which, for the first time, the group of Scottish artists known as the 'Glasgow Boys' exhibited together outside Scotland. Although the show provoked mainly hostile criticism, it firmly established the group in the eyes of the outside world as an artistic school. They had learned their use of strong colour and light and their broad handling of paint from the work of such artists as Corot and the French Impressionists. However, they were also influenced by the work of the English painter James Whistler, who was then probably better appreciated in Glasgow than almost anywhere else in Britain. His concern with formal colour arrangements and contrasts of light and dark tempered the spontaneity of the Glasgow Boys' 'impressionism' and helped them create an art that was stylish, distinctive and sufficiently modern to be immediately controversial.

The Grosvenor exhibition achieved more than a critical storm in London for it attracted an important group of visitors, including Adolphe Paulus, leader of the organisers of the International Exhibition in Munich. He was immediately impressed by the Scottish works and made arrangements for the Scottish painters to show in Europe. Eighty works by the 'Glasgow Boys' were shown at Munich that year, in addition to some by other Scottish artists. By the end of the decade over one thousand paintings by the 'Glasgow Boys' and others associated with them had been displayed at Munich, both at the Secession and at the Munich Art Society. Their work was bought by galleries all over Europe and a touring exhibition was taken to the USA in 1895.

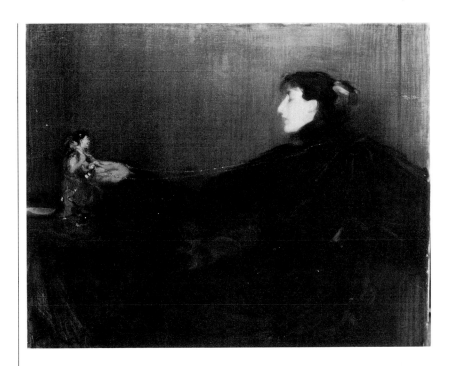

Figure 44
Robert Brough
The Fantasies of Madness
2.67

As a result, by the time of the first Vienna Secession exhibition in the spring of 1898, modern Scottish painting was well known and appreciated abroad.

This was especially true of the German-speaking countries, where development along parallel artistic lines was reinforced by the sympathy of the German and Austrian Secessionists for the Scottish artists in their fierce struggle against the hide-bound traditionalism of the Royal Scottish Academy and the Royal Academy in London. While the Germans and Austrians had felt it necessary to secede formally from the artistic Establishment of their own countries, the 'Glasgow Boys' and the other young Scottish artists of their day could be called 'natural' Secessionists. Indeed thirteen 'Glasgow Boys' were

made corresponding members of the Munich Secession in 1893 and John Lavery was a member of the Vienna, Munich and Berlin Secessions.

When the first Vienna Secession exhibition opened in 1898 it was not surprising, then, to find that Scottish artists figured prominently. E. A. Walton showed *The Flower Seller* (pl. 11), and J. W. Alexander, William Strang, John Lavery and Robert Brough also exhibited. The last showed *The Fantasies of Madness* at the second exhibition (fig. 43). However, the strongest representation of Scottish painting was at the fourth exhibition in spring 1899. Robert Burns, Joseph Crawhall, James Hamilton, Edward Hornel, William Kennedy, Bessie MacNicol, Harrington Mann, Macaulay

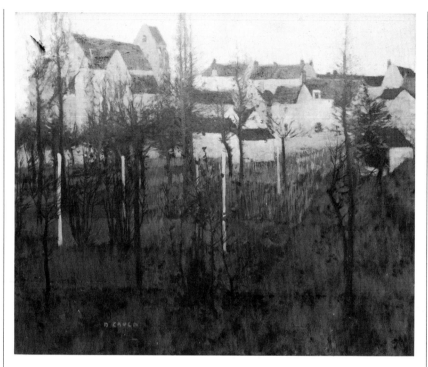

:THE·SECRET·OF·THE·WONDROUS·ROSE:

Figure 45
David Gauld
Grez seen from the River
2.68

Figure 46
Jessie King
The Secret of the Wondrous Rose
2.70

Stevenson and Grosvenor Thomas all exhibited, with David Gauld showing *Grez seen from the River* (fig. 44) and John Reid Murray showing *Autumn*.

The European links forged by these Scottish painters were undoubtedly responsible in part for establishing a favourable climate for further fruitful contact between the Viennese Secessionists and another, younger, generation of

Scottish artists and designers. Principal among these were the 'Glasgow Four': Charles Rennie Mackintosh, Herbert MacNair and Frances and Margaret Macdonald. Their work seems to have been well known on the Continent from sources such as Gleeson White's article in the *Studio* of 1897 and especially in the German-speaking countries from articles in the magazines *Dekorative Kunst* and

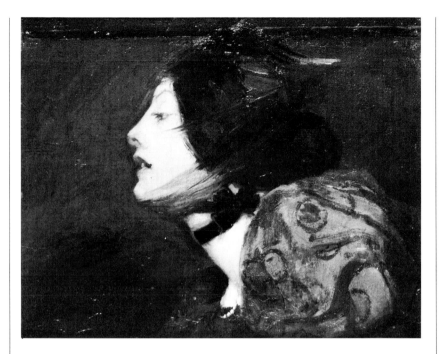

Deutsche Kunst und Dekoration. Mackintosh in particular was admired by the Austrian Secessionist designers who, with the eighth Secession exhibition, had an opportunity to give this admiration a more concrete form.

The organisation of this exhibition, which was to be principally devoted to the applied arts, was entrusted to Hoffmann, Moser and von Myrbach. In the late autumn of 1900 they invited the 'Glasgow Four' to decorate and furnish an entire room at the exhibition. (It is possible that on a trip to Britain in the spring of 1900 Fritz Waerndorfer, at Hoffmann's instigation, approached Mackintosh about contributing to the show.) Mackintosh was responsible for the decoration of the Scottish room and accomplished this in characteristic style. The walls and woodwork were all painted white, with no decoration except for a series of tapered square posts which divided the wall space into panels. These were attached to a deep wall plate which was inset with squares of coloured glass. The most striking features of the room's decoration, however, were the two large gesso panels, *The Wassail* by Mackintosh and *The May Queen* by Margaret Macdonald. Originally commissioned for Miss Cranston's Ingram Street tea rooms in Glasgow, they were set high up against the ceiling facing one another, giving the impression of a deep decorative frieze. Almost all the furniture, apart from a clock by Frances and Margaret Macdonald, seems to have been designed by Mackintosh and came largely from his Mains Street flat. The MacNairs exhibited relatively few pieces, including a wall cabinet and some framed book illustrations. The complete ensemble was stunning, its sparse simplicity contrasting markedly with the rather cluttered appearance of earlier exhibitions. It received great critical acclaim and delighted the Viennese public. When the Mackintoshes arrived in Vienna to see the exhibition they are reputed to have been drawn from the station, through the streets of the city, in a flower-decked carriage pulled by students.

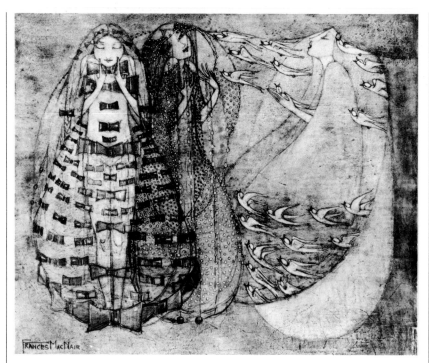

Figure 48
Francis MacNair
Bows, Birds and Beads
2.73

Figure 49
Josef Hoffmann
Carpet
2.82

Figure 50
Kolo Moser
Ex Libris for Fritz
Waerndorfer, 1903
2.84

The exhibition showed that the work of the Four was in complete harmony with that of the leaders of the Austrian movement and in fact it was obvious that the Scots, at this time, were the artistic leaders, while Hoffmann, Moser and the others were admiring followers. The impact of Mackintosh's sensational Room X was soon reflected in the works of the foremost Secessionists. Alfred Roller's designs for the next exhibition seem to indicate that lessons learned from Mackintosh's sparse, uncluttered interior had taken immediate effect. It would also be difficult not to detect certain echoes in the positioning and layout of Klimt's Beethoven Frieze produced for the

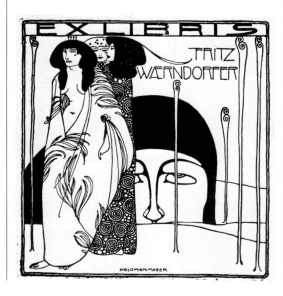

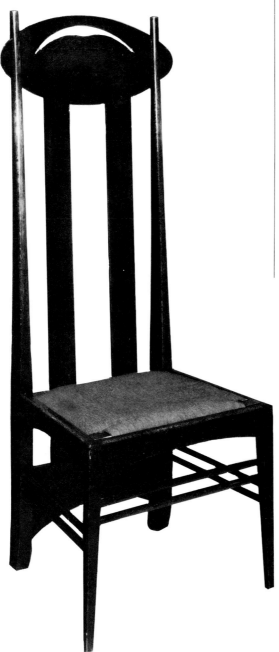

Figure 51
Charles Rennie Mackintosh
High-backed chair, 1897
2.80

fourteenth Secession exhibition in 1902. Hoffmann and Moser, in particular, among the Austrian designers appear to have been profoundly influenced by many of Mackintosh's ideas. His characteristic use of four squares grouped together was siezed upon by the Austrians to such an extent that it almost became a leitmotif. There is also a marked similarity between Mackintosh's cutlery designs and some of the silver produced by Hoffmann. It is undoubtedly significant that when Hoffmann, Waerndorfer and Moser were thinking about establishing a craft workshop project, later to become famous as the Wiener Werkstätte, it was to Mackintosh they turned for advice and encouragement.

2.63 Emil Orlik
Wooded mountain landscape, Loch Loss, 1898
Chalk and watercolour
12.7 × 20.2 cm
Ostdeutsche Galerie, Regensburg (Inv. No. OE 227)

2.64 Emil Orlik
Scottish Officer in Edinburgh, 1898
Pen and ink
20.7 × 12.8 cm
Ostdeutsche Galerie, Regensburg (Inv. No. OE 265)

2.65 Emil Orlik
Bagpiper, 1898
Black chalk
20.7 × 13 cm
Ostdeutsche Galerie, Regensburg (Inv. No. OE 259)

2.66 Edward Arthur Walton
Flower Seller: Kensington High Street, 1895
Watercolour
45 × 28 cm
Dr Camilla Uytman, Dundee
Shown at the first Vienna Secession exhibition, 1898.

2.67 Robert Brough
The Fantasies of Madness
Oil
102 × 126 cm
Tate Gallery, London
Shown at the second Vienna Secession exhibition, 1898.

2.68 David Gauld
Grez seen from the River
Oil
61 × 66 cm
Andrew McIntosh Patrick

2.69 John Reid Murray
Autumn, 1895
Oil
30.8 × 40.6 cm
Museum and Art Gallery, Glasgow
Shown at the fourth Vienna Secession exhibition, 1899.

2.70 Jessie King
The Secret of the Wondrous Rose
Ink on vellum
26.5 × 15.5 cm
Piccadilly Gallery, London

2.71 Bessie MacNicol
Study in Mauve and Green, c.1895
Oil
41 × 51 cm
Private collection

2.72 Frances MacNair
The Legend of the Snowdrops, 1900
Gouache on linen and paper
139.5 × 40.5
National Museum of Antiquities of Scotland (Inv. No. SVB 6)
Inscribed: When ice-flakes fell in showers upon/that World of Death/Some pitying ones distilled by Angel-breath/fell loving flowers/And Snowdrops thus were born to comfort Eve/who sorrowful the Land of Life did leave.
From Dunglass Castle, Bowling, Dunbartonshire.

2.73 Frances MacNair
Bows, Beads and Birds
Mixed media
29.3 × 35 cm
Piccadilly Gallery, London

2.74 Margaret Macdonald
Summer, 1904
Gesso panel
100.7 × 43.2 cm
National Museum of Antiquities of Scotland (Inv. No. SVB 4)
From Dunglass Castle, Bowling, Dunbartonshire. Title on the basis of the similarity between this panel and the watercolour *Summer*, 1897, now in Glasgow Art Gallery and Museum.

2.75 Charles Rennie Mackintosh
Autumn, 1894
Watercolour and pencil
28.2 × 13.3 cm
Glasgow School of Art

2.76 Charles Rennie Mackintosh
Design for the large version of the *Scottish Musical Review* poster, 1895-6
Watercolour and pencil
37.3 × 17.1 cm
Hunterian Art Gallery, University of Glasgow: Mackintosh Collection

2.77 Charles Rennie Mackintosh
Poster for the *Scottish Musical Review*, 1895-6
Colour lithograph
246 × 101.5 cm
Hunterian Art Gallery, University of Glasgow: Mackintosh Collection
Large version.

2.78 Catalogue of the eighth Vienna Secession exhibition, 1900
Michael Collins
A reconstruction of the 'Scottish room' at the eighth Vienna Secession exhibition, at which works by Charles Rennie Mackintosh and the artists of his circle were shown, can be seen concurrently with the present exhibition at the Fine Art Society, 12 Great King Street, Edinburgh.

2.79 *Ver Sacrum*
Volume IV (1901), No. 23
Hunterian Art Gallery, University of Glasgow: Mackintosh Collection
Scottish issue.

2.80 Charles Rennie Mackintosh
High-backed chair, 1897
Oak, with upholstered seat
132.3 × 49.7 × 47.1 cm
Victoria & Albert Museum, London (Inv. No. Circ. 130 - 1958)
Duplicate of a chair shown at the eighth Vienna Secession exhibition, 1900.

2.81 Postcard from Lily Waerndorfer to Mr and Mrs Chas. Mackintosh, with a view of the interior of the eighth Vienna Secession exhibition, 1900.
Hunterian Art Gallery, University of Glasgow: Mackintosh Collection
Fritz Waerndorfer was an enthusiastic patron of the Secession and co-founder with Hoffmann and Moser of the Wiener Werkstätte. In 1901–2 he commissioned from Mackintosh the decoration and furnishing of an entire music room, and from Hoffmann the decoration and furnishing of an entire dining room, for his house in the Viennese suburb of Währing. Relations between the Waerndorfers and the Mackintoshes seem to have been most cordial, as this postcard from Waerndorfer's wife Lily attests.

2.82 Josef Hoffmann
Carpet
492 × 300 cm
Fischer Fine Art Ltd., London
The carpet was designed c.1902-4 for Fritz Waerndorfer's house in Währing, and made by the firm of J. Backhausen und Söhne, Vienna.

2.83 Josef Hoffmann
Items from a canteen of cutlery
Silver

a. Table knife, length 21.4 cm

b. Table fork, length 21.5 cm

c. Table spoon, length 21.8 cm

Oesterreichisches Museum für angewandte Kunst, Vienna (Inv. No. Go.2009)
With monogram of Lily and Fritz Waerndorfer.

2.84 Koloman (Kolo) Moser
Ex Libris for Fritz Waerndorfer, 1903
Lithograph
15.5 × 15.8 cm
Galerie Michael Pabst, Munich - Vienna
The somewhat Beardsley-esque character of this Ex Libris recalls the fact that Waerndorfer was an enthusiastic collector of the British artist's work.

2.85 Margaret Macdonald
The Mysterious Garden, c.1904-6
Watercolour and pencil
28.8 × 83.5 cm
Hunterian Art Gallery, University of Glasgow: Mackintosh Collection
The subject of this watercolour is related to a series of gesso panels made by Margaret Macdonald to decorate the upper walls of Fritz Waerndorfer's music room. The panels, now lost, were based on Maeterlinck's play *Les Sept Princesses*.

2.86 Charles Rennie Mackintosh
Cabinet, 1902
Ebonized wood, with metal, glass and gesso panels by Margaret Macdonald
184 × 124 × 30 cm
Oesterreichisches Museum für angewandte Kunst, Vienna
The cabinet once stood in Fritz Waerndorfer's house in Währing, although not, as photographs show, in the now lost Mackintosh music room.

2.87 Charles Rennie Mackintosh
Items from a canteen of cutlery, 1902
Silver

a. Serving spoon, length 27 cm

b. Fork, length 25.8 cm

c. Ladle, length 23.2 cm

British Museum (Inv. No. M&LA 1980. 1-4. 1-3)
The cutlery was designed for Jessie Newbery, and shows a marked similarity to Hoffmann's elongated, rectilinear designs of the same period.

2.88 Charles Rennie Mackintosh
Drawings for items from a canteen of silver cutlery, 1902
Pencil and wash
25.3 × 69 cm
Hunterian Art Gallery, University of Glasgow: Mackintosh Collection
Preparatory drawing for Jessie Newbery's cutlery; compare cat. no. **2.87**.

2.89 Charles Rennie Mackintosh
Items from a canteen of cutlery
Silver

a. Soup spoon, length 26.6 cm

b. Meat fork, length 26 cm

c. Dessert spoon, length 23.5 cm

d. Dessert fork, length 23.5 cm

Mary N. Sturrock (nee Newbery), Edinburgh

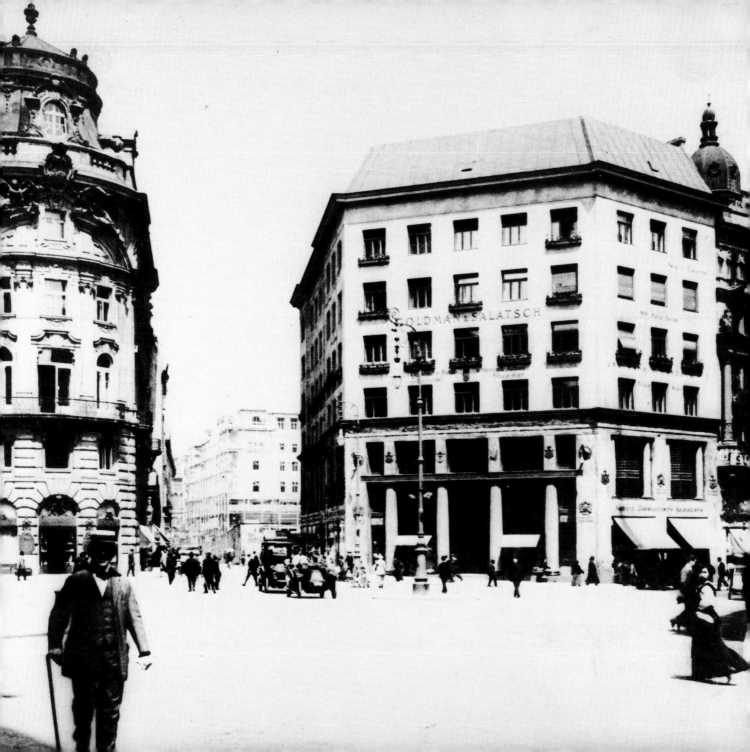

Figure 52
Adolf Loos's department
store for Goldman und
Salatsch on the
Michaelerplatz, Vienna

The eighteenth Vienna Secession exhibition, which opened in November 1903, was entirely devoted to the work of Klimt. It provided the first opportunity for critics and public to gauge the scope and variety of the artist's work. Klimt had brought together for the occasion nearly all his important paintings to date, including a representative selection of landscapes and portraits (among them the still unfinished portrait of Hermine Gallia, pl. 16, and the 1903 *Birch Wood,* pl. 7), the three paintings done for the great hall of Vienna University, shown together for the first time and also described as 'unfinished', and the Beethoven frieze which, being a fresco, had remained *in situ* ever since the Secession's Beethoven exhibition the previous year (fourteenth Vienna Secession exhibition, 1902). The showing of the third of the university paintings, *Jurisprudence,* together with its companion pieces, almost certainly stiffened the resolve of the university authorities not to permit Klimt's pictures to be installed in their intended setting, setting in train the inevitable confrontation between the artist, the university and the Ministry of Education who had commissioned the paintings in the first place.

The juxtaposition of so many of Klimt's early paintings under one roof made clear the extraordinary eclecticism of this period of his work. The influence exerted by several of the most important 'corresponding members' of the Secession, among them Beardsley and Khnopff, would have been clearly apparent, as well as that of more arcane sources such as Byzantine mosaics and Mycenaean ornament. But it was equally apparent that Klimt was the outstanding personality among the painters of the Secession, and that he was able to synthesize the diverse sources on which he drew into images of extraordinary power. For the first time, Bahr observed, Vienna was again able to boast of a decorative painter of the stature of Makart.

Ironically, for Klimt himself this major retrospective exhibition marked the beginning of a phase of uncertainty and greater isolation. He had no serious difficulty in selling his works, and continued to receive a steady stream of lucrative portrait commissions such as that for the portrait of Margaret Stonborough-Wittgenstein, daughter of Karl Wittgenstein who had supported the Secession in its early days. But he was weary of the malice of his critics, and increasingly depressed by the unresolved arguments over the fate of the three university paintings. Moreover, the dominant position of himself and his closest friends like Hoffmann and Moser had begun to produce tensions and jealousies within the Secession. In general, groups of rebel artists tended to be rather unstable entities, polarising into mutually hostile factions or even forming new splinter groups (as happened in Berlin, where the original Secession finally gave birth to two further, opposing societies calling themselves the 'new Secession' and the 'free Secession'). In Vienna, matters came to a head in 1905, and after several disputes the 'Klimt-group' declared its resignation from the Secession, though it formed no new organization as such. Instead, the more radical of the former Secessionists together with a number of younger artists rallied around Klimt to

Figure 53
Egon Schiele

Figure 55
Gustav Klimt
Drawing for the portrait of
Hermine Gallia, 1903
3.2

Figure 54
Jewish street vendor selling
ribbons
In the early 1900s, the inner
city still showed the most
extreme contrasts of wealth
and poverty

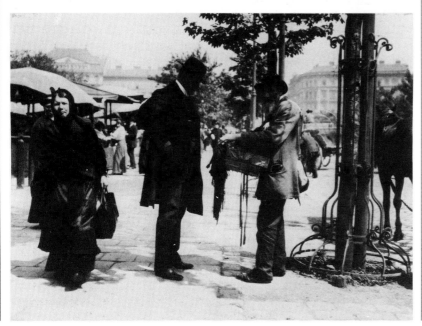

stage two major exhibitions in 1908 and
1909, intended to rival the Secession's own
exhibitions, which went under the title
simply of *Kunstschau*—art show.

Another cause of tension within the
Secession had been what some members
saw as the dominance of the applied arts at
the expense of easel painting and the
involvement of Hoffmann and Moser in
particular with their newly founded
commercial enterprise, the Wiener
Werkstätte. The Wiener Werkstätte had
been set up in the summer of 1903 with
Mackintosh's encouragement and the
example of Ashbee's Guild of Handicrafts

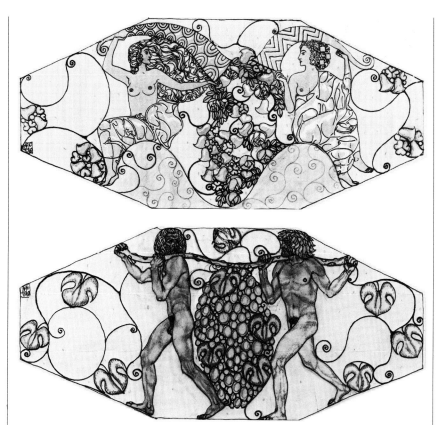

Figure 56
Carl Otto Czeschka
Designs for bronze reliefs in
the Palais Stoclet
3.6&7

number of other artists allied themselves with Hoffmann and Moser and began executing designs for the WW, among them Carl Otto Czeschka, Gustav Klimt and the sculptor Richard Luksch.

The Wiener Werkstätte's activities soon embraced almost every aspect of the applied arts: not only furniture and interior design but metalwork, jewellery, fine bindings, wallpapers and textiles. A further offshoot of the Wiener Werkstätte idea was the formation of the Wiener Keramik-Werkstätte (Vienna Ceramic Workshop) in 1906, under the direction of Michael Powolny and Dagobert Peche. The WW itself, however, did not actually produce ceramics or glassware, entrusting their designs to manufacturers such as Lobmeyr, Bakalowits and Böck for execution.

In the autumn of 1907 Waerndorfer diversified his interests still further by taking on the running of the literary and satirical cabaret christened the *Kabarett Fledermaus*, for which the designers of the Wiener Werkstätte produced not only the furnishings and decor, but also graphic designs for the posters and programme books. Graphic art now began to assume an important role within the activities of the WW, who began publishing picture books and illustrated broadsheets, as well as a whole series of postcards, comprising greetings cards and fashion designs, satirical vignettes and scenic views, and depictions of events in which some of the WW artists themselves were involved such as the *Kunstschau* or the Imperial Jubilee pageant of summer 1908.

The quality and diversity of its products are sufficient in themselves to guarantee the Wiener Werkstätte a significant place in

firmly in mind. Fritz Waerndorfer, who provided most of the necessary capital, became financial manager. In conformity with the Arts and Crafts ideal of the totally designed interior the WW advertised itself as being ready to undertake furnishings, interior designs and the building of entire houses, and in fact within the first two years of its existence received commissions for two major architectural projects: the building of a sanatorium at Purkersdorf, just outside Vienna, and of an entire town palace in the suburbs of Brussels for the Belgian industrialist Adolphe Stoclet. Partly as a result of the latter commission, a

the history of modern design. Although the debt to the English Arts and Crafts movement, and the influence of Mackintosh, are undeniable, the designers of the WW soon distanced themselves from the sources on which they drew, creating objects which, at their best, display a geometrical elegance and simplicity quite unlike anything else produced in Europe at this time—a far cry from the sinuous forms of French *art nouveau* glassware, for example, and different again from the floral aspect of German *Jugendstil*.

Yet as a business venture, the WW was doomed from the start. We can marvel at the costly materials, the hand tooled leather bindings, the silverware set with semi-precious stones, but the emphasis given to the art of the individual craftsman, the cult of refinement at the expense of all other considerations, and the practice of producing designs only in response to specific commissions soon led to financial problems. It has been suggested that these problems stemmed largely from over-diversification, and from Waerndorfer's involvement with the *Kabarett Fledermaus*. However, a letter from Waerndorfer to Hoffmann shows that, as early as 1906, the WW was already in difficulties, exacerbated by a dispute over payment for the completion of the sanatorium at Purkersdorf. In the event, the commission for the building of the Palais Stoclet tided them over, and the WW carried on lurching from one financial crisis to another until, in the winter of 1913, production ground to a halt and newspaper reports estimated the firm's accumulated debt as in excess of one million crowns. In May 1914 a penniless

Fritz Waerndorfer, who had lost his entire family fortune in the enterprise, emigrated to the United States, leaving behind his wife and their unsaleable house, the Mackintosh and Hoffmann interiors by now a positive drawback in the eyes of any potential buyer.

Apart from any question of financial instability, the Wiener Werkstätte had from the first incurred a good deal of criticism on quite different grounds. Even friends like Peche and Eduard Josef Wimmer commented on the dictatorial character of the WW aesthetic, on the fact that a WW interior could not be changed even in its smallest details for fear of

disrupting the unity of the designer's artistic conception. That harmony was also in danger of being destroyed by the intrusion of people, who constituted a jarring note within this hermetically conceived world—unless, of course, they also happened to be dressed in WW-designed clothes, a consideration which led to the establishment of the firm's fashion department in 1910.

Other artists, less well disposed, remarked acidly on what they saw as the Wiener Werkstätte's misconceived aims in the field of interior design. One of their most outspoken critics was the architect Adolf Loos, himself a successful designer

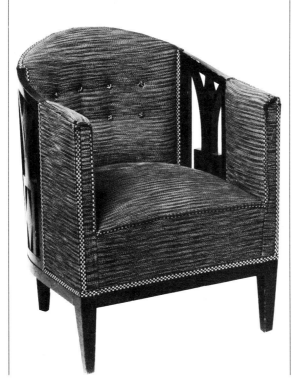

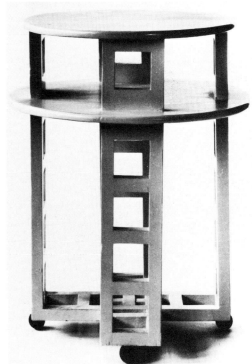

of both commercial and domestic interiors. Loos was a caustic and critical writer, as well as a witty and sardonic one, and he lost no opportunity of attacking Hoffmann in particular, for whom he seems to have conceived a special dislike. His polemic is at first sight a little surprising, since around the turn of the century Loos had been far closer to the Secessionists than he later cared to admit, even publishing one of his best known articles, 'Potemkin's Town', in the Secession's magazine *Ver Sacrum*. He also commented in general rather favourably on Secessionist work in his exhibition reviews, even evincing a grudging admiration for their achievements in the field of exhibition design.

The Wiener Werkstätte, on the other hand, represented an aesthetic standpoint to which Loos could not possibly subscribe. They aimed at breaking down the barriers between artist and craftsman, whereas Loos drew a fundamental distinction between the respective role of the 'fine' and 'applied' arts. The WW employed only the finest craftsmen, whose monograms appear alongside that of the designer on items of silver and metalware—a far cry from the example of the 'anonymous' medieval craftsman to which Loos pointed repeatedly. They prided themselves on the use of costly materials, whereas Loos would often choose for preference simple materials like brass or linoleum. Only their common enthusiasm for the English 'style' remained as a point of contact. In Loos's case, however, although this enthusiasm was deeply felt it remained of a rather vague and unspecific nature, as opposed to the emulation or adaptation of particular stylistic models sometimes found in Hoffmann's work.

For Loos, the art of the designer consisted not in imposing some fixed aesthetic standpoint on his hapless client, but in selecting and juxtaposing the simplest and most convenient, and therefore most elegant objects of common use. For this reason, examples of original Loos furniture are comparatively rare. He would often prefer to go out and buy what was required second-hand, and for a very modest price, seeing in Viennese nineteenth-century furniture of the Biedermeier period the expression of a concern for logic and utility which, when he did sit down and design a chair or a sideboard himself, he sought to emulate in his own work. What he hated, on the other hand, was decoration used purely from force of habit, ornament for its own sake. In his celebrated essay 'Ornament and Crime', he attacked this kind of conventional, meaningless decoration as symptomatic of a state of barbaric degeneracy and pointed, with his tongue ever so slightly in cheek, to the high incidence of tatooing among the inmates of Vienna's prisons.

Unfortunately for Loos, the question of ornament, especially ornament in an architectural context, would not go away. In 1910 he received a commission to design a new department store on Vienna's Michaelerplatz (fig. 51), a commission that was to involve him in endless difficulties. His client was the firm of Goldman und Salatsch, from whom he had been buying his clothes since the turn of the century. (Loos, passionate Anglophile, was also something of a dandy both in costume and in speech: he dressed fastidiously in the

Figure 61
Kolo Moser
Vase
3.19

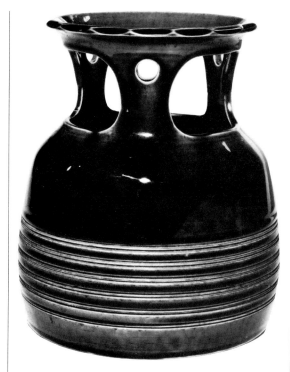

Figure 62
Michael Powolny
Figure of a young lady,
standing
3.23

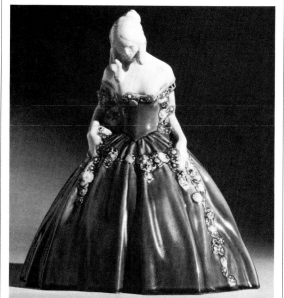

Figure 63
Bertold Löffler
Pallas Athene, 1908
3.21

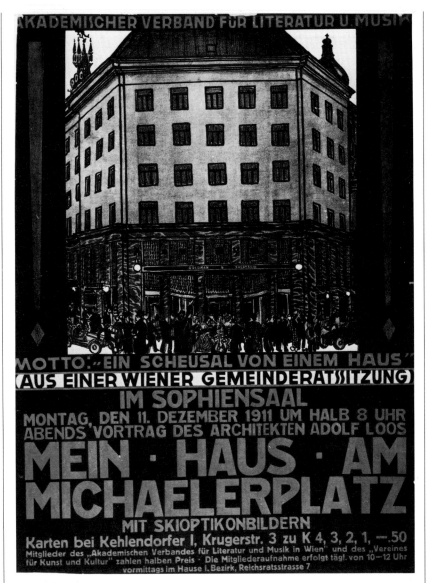

'English' manner, and peppered his writings with Anglicisms and English phrases such as 'hands off!' Interestingly, the second number of his magazine *Das Andere* carries a front-page advertisement for Goldman und Salatsch which describes them, in English, as 'tailors and outfitters'.)

Loos was in fact on excellent terms with his patron, Leopold Goldman, who stood by him throughout the tribulations occasioned by the new building. Rather, the problem was the site, in the historic centre of Vienna, right opposite one of the main entrances to the imperial palace. It was not the plan of the building, nor its

Figure 64
Adolf Loos
Poster advertising a lecture, 1911
3.30

scale, which was perfectly in keeping with the adjacent shops and office blocks, but the appearance of the main facades that caused dismay and hostility among press and public. Loos made several revised designs for the facades, which enable us to follow clearly his uncertainties, his changes of mind, and his somewhat half-hearted attempts to comply with the demands imposed by the city authorities. These demands included holding up work on the building for months at a time while other architects submitted alternative schemes, and at one point Loos retired to a sanatorium with a near nervous breakdown brought on by the whole affair. But when the facades were finally completed, the effect was more startling than anyone had anticipated, the unadorned window openings and entirely blank facade of the upper storeys contrasting starkly with the rich marble and imposing Doric colums of the main portal. Interestingly, these columns with their unashamed classical allusions were, as the drawings demonstrate, not an afterthought, nor a compromise forced on the architect by his enemies, but an integral part of his original conception. Loos himself, taking as his theme the phrase used against him by one of his critics, 'a horror of a house', vigorously defended his new building in a lecture given before the Academic Society for Literature and Music in December 1911, under the title 'My house on the Michaelerplatz' (fig. 63).

The furore over the building of the new department store naturally did nothing to sweeten Loos's temper. Nor did it cause him to revise his opinion of his fellow Viennese, for whom in the main he evinced a deep contempt. He was constantly pointing to the backwardness of Austria as a whole, not just in the realm of art, but across the whole spectrum of culture, social distinctions, sanitation, even cuisine. His magazine *Das Andere* was subtitled pointedly 'A Newspaper to Introduce Western Culture into Austria'.

On the other hand, he had a high regard for a small number of fellow artists, and to these few he remained fiercely loyal. He was on friendly terms with the writer Karl Kraus, who shared his disdain for the Wiener Werkstätte. While Loos was especially hostile towards Hoffmann, Kraus seems particularly to have disapproved of Waerndorfer, being one of the first to attack the 'pseudo culture' of Waerndorfer's newly opened *Kabarett Fledermaus*. Kraus and Loos occupied rather similiar positions within their respective worlds: a parallel might be drawn, for example, between Kraus's view of the 'moral' function of language and Loos's conception of morality in architecture. They were also somewhat similar as stylists, the mocking and satirical tone of *Das Andere* being matched by that of Kraus's journal *Die Fackel* (The Torch), which he at first edited and later wrote single-handed.

Loos was also a fervent supporter of the young Oskar Kokoschka. Kokoschka described him as 'my Virgil, who led me through the heaven and hell of human experience.' They first became acquainted in 1909, shortly after Kokoschka had 'escaped' from the clutches of the Wiener Werkstätte. (He had done some postcards for the WW, who also published his volume of poems and lithographs *Die Träumenden Knaben*—The Dreaming Youths. In addition, Waerndorfer bought

Figure 65
Oskar Kokoschka
Karl Kraus, 1909
3.32

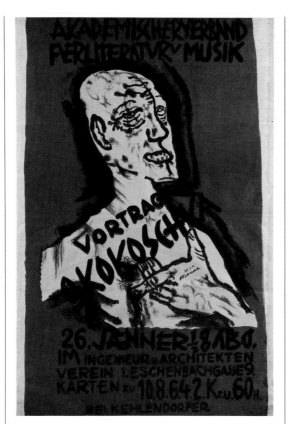

Figure 66
Oskar Kokoschka
Poster advertising a lecture,
1911
3.67

whose fable *The Great Wall of China* he also made a series of lithograph illustrations, and Albert Ehrenstein, whose book *Tubutsch* was also illustrated with 12 etchings after drawings by Kokoschka.

Portraiture occupied an important place within Kokoschka's work of this pre-war period. Not that his portraits always pleased his sitters, since the artist showed an engaging lack of concern with his clients' wealth, or status, or even profession. In his portrait of Loos, for example, there is nothing whatever to suggest the architect, no drawing board, no plans and elevations, none of the paraphernalia that would have been *de rigueur* in a nineteenth-century portrait. Nor did Kokoschka regard it as his task to try to capture an accurate physical likeness. As he himself put it, he was not concerned with the 'externals' of a person; for him, it was more important to cast light on the sitter's psyche than to enumerate details like five fingers, two ears, one nose. This importance placed on psychological penetration meant that, in all his portraits, particular emphasis is given to the hands and especially the eyes of the sitter. 'What used to shock people about my portraits', Kokoschka wrote, 'was that I tried to intuit from the face, from its play of expressions, and from gestures the truth about a particular person. In a face I look for the flash of the eye, the tiny shift of expression that betrays an inner movement.'

This importance given to the 'internal' at the expense of the 'external', the insistence on psychological truth instead of truth to nature is something we have come to recognize as one of the hallmarks of Expressionism. Expressionism was not a style of painting, nor indeed was it

work by Kokoschka from the 1908 *Kunstschau*, and commissioned him to make stage designs for the 'shadow plays' performed at the *Kabarett Fledermaus*.) In the same year, Kokoschka painted Loos's portrait (pl. 20), and Loos lost no time in introducing the young painter to other potential clients like the Court tailor Ernst Ebenstein. He also personally commissioned the portraits of several of his friends, among them the journalist and publisher Ludwig von Ficker. In the years before 1914, Kokoschka drew and painted some of the most important literary figures of the day, including Kraus (fig. 64), for

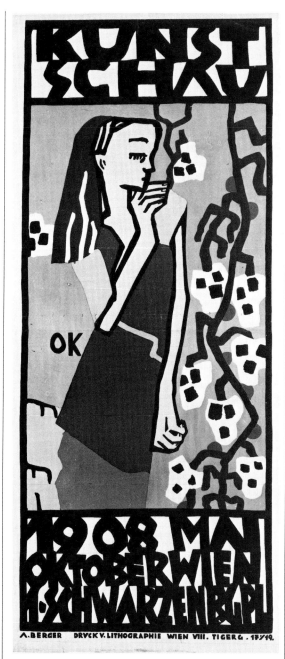

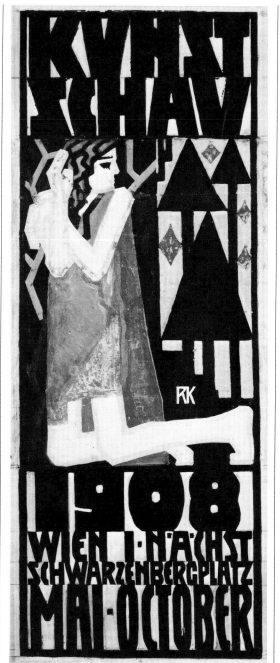

confined to painting alone: rather, it was a philosophy or *Weltanschauung,* a set of beliefs shared by artists working in a variety of media. Artists began to shun the task of recording or depicting external events, seeing themselves instead as chroniclers of 'events of an inner character'. The primacy given to the artist's own inner experience had a number of consequences. For one thing, formal training, skill in the manipulation of a given medium were classed as 'external', and therefore irrelevant. Schoenberg's dictum 'Art comes from necessity, not from ability' became one of the watchwords of the new movement. For another, artists began to regard the medium itself as an external and therefore unimportant element, since the only important thing was not the 'form', but the 'content' the artist felt compelled to convey. As a result, those artists who had perhaps trained as painters or composers started to feel quite uninhibited about their lack of formal qualifications as poets or dramatists or sculptors, and started to cross more and more frequently the boundaries that had traditionally divided one art form from another. This phenomenon, too, is one of the distinguishing characteristics of Expressionism, and was extremely widespread during the early years of this century.

Kokoschka, like so many of his Expressionist contemporaries, experimented in a wide variety of different media. In the years before 1914, he not only made paintings, drawings, prints and sculptures, but also wrote poetry, plays and essays. His most remarkable contribution to the second *Kunstschau*

exhibition was his play *Murderer Hope of Women,* first performed at the open-air theatre attached to Hoffmann's temporary exhibition building in July 1909. The artist himself recalled that, for lack of money, he dressed the actors in makeshift costumes of rags and scraps of cloth, and painted their faces and bodies where exposed, decorating their arms and legs with 'nerve-endings, muscles and tendons, just as they can be seen in my drawings.' Four of the drawings, together with the text of the play, were published the following year, 1910, in Herwarth Walden's Berlin periodical *Der Sturm,* in many respects the principal organ of the Expressionist movement.

Kokoschka, as it happens, left a number of contradictory statements about his play, and its relation to literary Expressionism. On one occasion, he stated that *Murderer* had 'nothing to do with that rejection of society or plans for the improvement of the world such as characterise the literary breakthrough and change in style which is called Expressionism.' (It is perfectly true that Kokoschka was not called an 'Expressionist' by any critic at the time: the tag *Oberwildling* invented by the writer Ludwig Hevesi might best be translated as 'super-*Fauve*'.) The artist also denied that his play had anything to do with 'influences from Freud or Claudel. I don't go in for such interpretations. It simply expresses my attitude to the world.' He did, however, acknowledge later that, 'if the label Expressionism has any meaning', then the poster advertising the play (fig. 00) was one of its earliest manifestations. Moreover, the play itself has evident points of contact with Expressionist theatre, with its curious mixture of

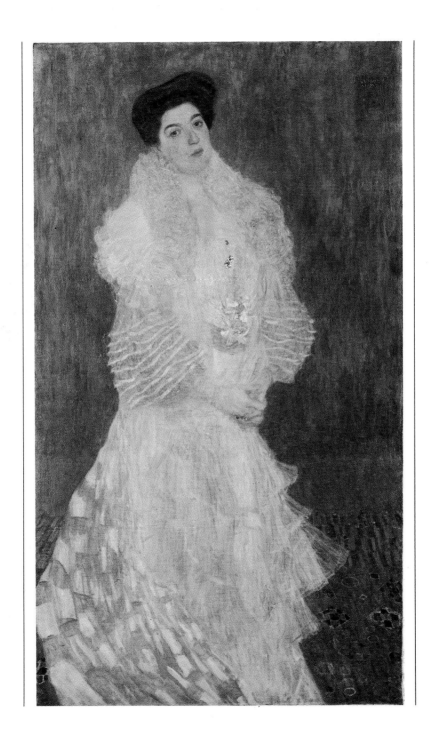

Plate 16
Gustav Klimt
Hermine Gallia, 1904
3.1

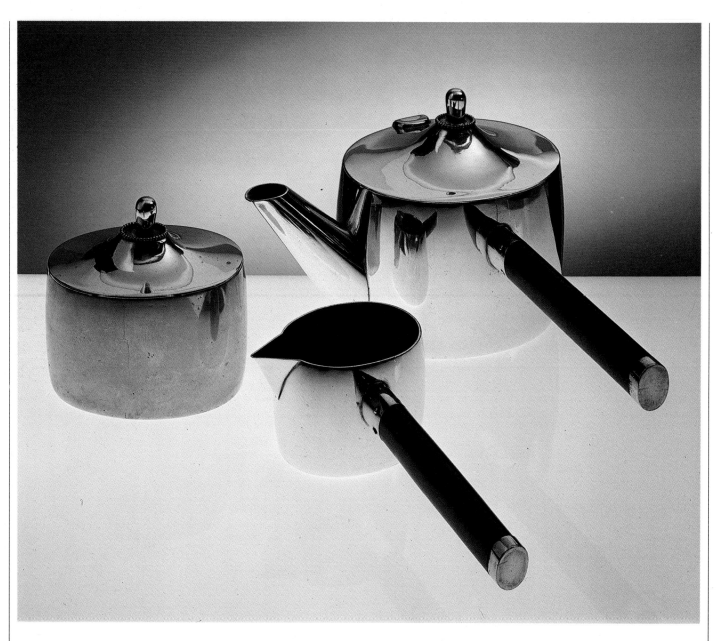

Plate 17
Josef Hoffmann
Coffee set, *c.*1909
3.15

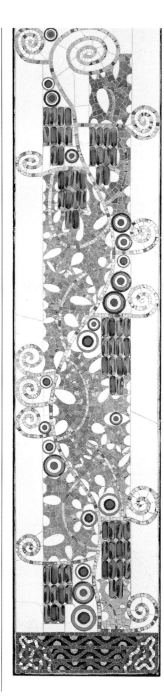

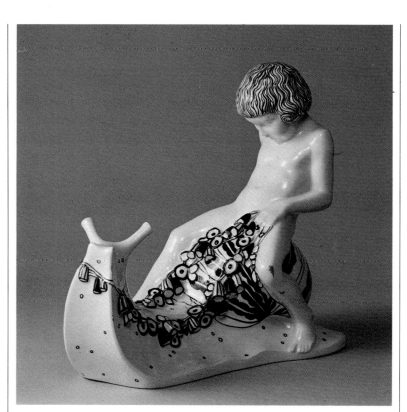

Plate 19
Michael Powolny
*Boy on a snail, c.*1907
3.22

Plate 18
Leopold Forstner
*Mosaic with scrolls, c.*1908
3.20

Plate 20
Oskar Kokoschka
Adolf Loos, 1909
3.31

Plate 21
Arnold Schoenberg
*Garden at Mödling, c.*1908
3.39

Plate 22
Egon Schiele
Houses at Krumau, 1908
3.47

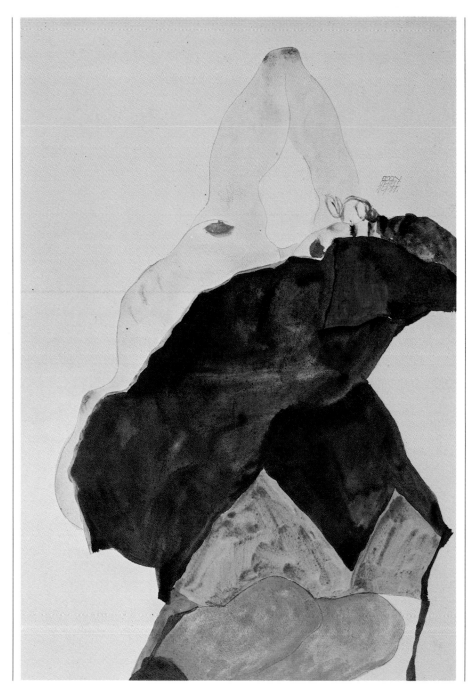

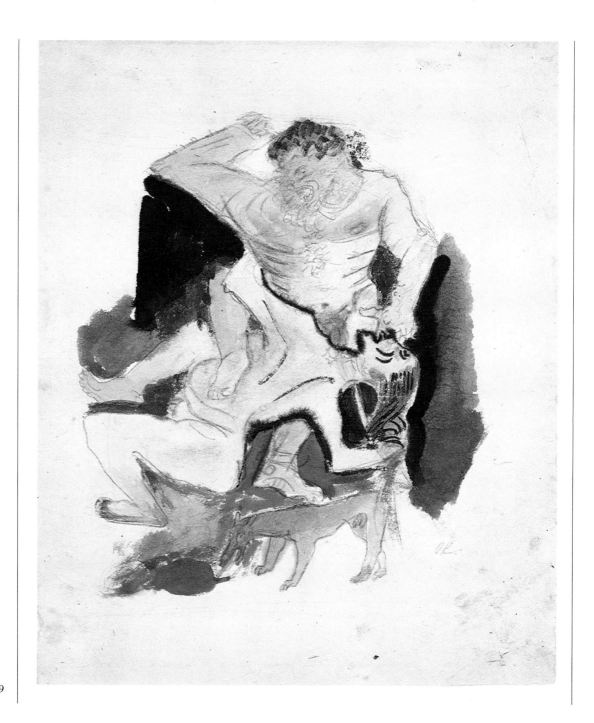

Plate 24
Oskar Kokoschka
Murder of a Woman, 1908–9
3.65

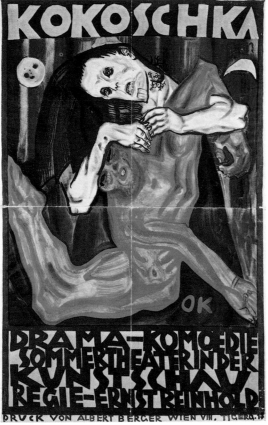

Plate 25
Oskar Kokoschka
Poster advertising the
*Sommertheater in der
Kunstschau 1909*
3.64

Plate 26
Bertold Löffler
Poster 'Grandes fêtes . . .
l'Empereur', 1908
3.77

why do you slumber
blue clad men
in the moonlight beneath the branches
 of the dark walnut tree?

gentle women
why do your bodies your entwined
 limbs gush with expectation
beneath your red gowns
since yesterday and evermore?

can you feel the excited warmth of the
 trembling tepid air?
—I am the circling werewolf

at the sound of the evening bell
I slip into your gardens
into your meadows
break into your peaceful pastures

my untamed body
my body heightened with blood
 and paint
creeps into your leafy hovels
roves through your villages
creeps into your souls
roves through your bodies

for you I howl
out of the lonely silence
in the hour before waking

I devour you
men
women
half-waking listening children
the wild loving werewolf within you

from Die Träumenden Knaben by Oskar Kokoschka

eroticism and brutality, its interwoven themes of violence, subjection and bondage.

The same mixture can be found in the poems Kokoschka published the preceding year under the title *Die Träumenden Knaben* (The Dreaming Youths). *Die Träumenden Knaben* was intended as an illustrated children's book with accompanying colour lithographs; but Kokoschka by his own account did not really adhere to the original commission, creating instead 'an account in words and pictures of my spiritual state at that time.' The lithographs, which he described as a 'kind of free versification in pictures', are for the most part innocuous enough; but the poems are of a kind to give even a child of only moderate sensibilities screaming nightmares, an odd blend of the erotic, the brutal and the fanciful.

Far from being unique, Kokoschka's remarkable, multi-facetted talent finds a close parallel in the founder of the so-called second Viennese school in music, the composer Arnold Schoenberg. Today, we remember principally Schoenberg's musical innovations of these years before the First World War, his progressive abandonment of tonality in works like his *Second String Quartet* or the song cycle *Das Buch der hängenden Gärten*. But in addition to composing music, Schoenberg also wrote theory and criticism, the libretto for his own opera *Die Glückliche Hand* (The Lucky Hand), and made set designs both for *Die Glückliche Hand* and for his monodrama *Erwartung* (Expectation). He also painted pictures, priding himself on having achieved a measure of recognition even among 'professional' painters. And indeed, paintings by Schoenberg were

shown at the first 'Blue Rider' exhibition in Munich in December 1911; while the famous *Blue Rider Almanac,* edited by Kandinsky and Franz Marc and published in Munich six months later, in May 1912, also contained reproductions of his paintings, his essay 'The Relationship to the Text', and a facsimile of his song-setting of Maeterlinck's poem *Feuillages du Coeur.*

By the time the *Blue Rider Almanac* appeared, Kandinsky himself had paid written tribute to Schoenberg the painter in an essay called simply 'The Pictures', published in an anthology in honour of Schoenberg edited by Alban Berg. Kandinsky's essay is useful since the quick eye of the 'professional' painter distinguished between two opposing tendencies in Schoenberg's art: the naive and the visionary. Apart from his stage designs and relatively few landscapes (pl. 21), Schoenberg's paintings fall into two quite distinct groups: portraits, and a series of nightmarish, disembodied faces which went under the title of *Gaze* or *Vision* (figs. 68-71). The portraits depict, for the most part, either Schoenberg's own features (like many amateur painters, he was his own most frequent model) or those of his friends and pupils, like Alexander von Zemlinsky (fig. 85) and Alban Berg. These works have an undoubted historic interest, and one cannot deny their naive directness

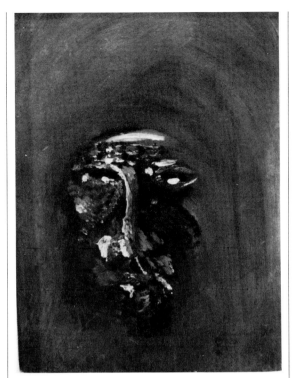

development as a painter, a suggestion which Schoenberg, who had personal reason to shun Gerstl's memory, emphatically denied. There are, however, important points of contact between the two artists, in their treatment of landscape, their handling of paint, and Gerstl's way of accentuating the eyes of the people he portrayed, causing them to stand out from a thick sea of paint—a device Schoenberg carried to even greater intensity by abbreviating or omitting everything apart from the eyes in his haunting, uncanny *Gazes*.

Of the other artists who crossed the boundaries between different art forms, the most significant was the painter Egon Schiele. As in the case of Gerstl, Schiele's precocious talent was cut short when the artist was still in his twenties, albeit not by his own hand, but by the epidemic of Spanish influenza which ravaged Europe in 1918. In other respects, however, the most instructive parallels are to be drawn not with Gerstl's but with Kokoschka's early career. Like Kokoschka, Schiele showed remarkable artistic talent at an early age. His first portraits and landscapes, done when he was only fifteen or sixteen, have a surprising refinement and sureness of touch. Like Kokoschka, he started as a boy to write short prose poems, though the weird imagery of Kokoschka's verses is absent from Schiele's literary experiments. Both artists acknowledged the debt they owed Klimt, to whom Kokoschka dedicated *Die Träumenden Knaben* 'in the deepest reverence'. Kokoschka's earliest pictorial works, however, show little stylistic influence from Klimt, whereas it took Schiele several years to absorb the impact of the

of expression; but as regards their effect, they are eclipsed by the so-called *Gazes*, an extraordinary group of paintings one can only describe as a series of highly abstracted stares. These works have no real parallel in Expressionist painting, the nearest comparison being with the work of the young Austrian artist Richard Gerstl, whose suicide in 1908, at the age of only 25, terminated a tragically brief career.

Gerstl preferred the company of musicians to that of painters, and lodged for a time in Schoenberg's house, depicting the composer and his family in a succession of individual and group portraits (fig. 00). It has been suggested that his work exerted a formative influence on Schoenberg's

older artist's style, even reworking a number of Klimt's compositions in his own canvases such as *Watersprites*, or his portrait of the painter Anton Peschka.

Schiele's mature work, from about 1910 onwards, shares with that of Kokoschka and Gerstl some of the most important characteristics of Expressionist painting generally. His portraits, like Kokoschka's, are devoid of conventional trappings, the attributes of wealth or breeding or position. Schiele began setting his figures against an entirely blank, loosely brushed background, heightening the expression by anatomical distortion and the use of unaccustomed poses. These strange contortions and 'expressive' gestures recall his interest in the art of contemporary mime artists like Mime van Osen, whose portrait he painted. This interest, and his fascination with photography, combined to produce some extraordinary images of Schiele himself, striking a pose in front of the mirror for the benefit of the camera, pouting and gesticulating in what might be seen as the modern equivalent of an eighteenth-century *tête d'expression*.

There is also an evident brutality in some of Schiele's work of the years before the Great War, particularly his self portraits. Like Schoenberg, Schiele was his own most frequent model, but no other painter, not even Schoenberg, ever subjected himself to such savage and merciless scrutiny. In the great *Seated male nude* of 1910, the 'amputated' hands and feet in this allegorical self portrait still have the power to frighten and shock. But alongside this strain of brutality there exists an element of compassion in Schiele's work, seen especially in his depictions of children, the pinched faces of the Viennese suburbs, or

Figure 72
Egon Schiele
Seated Woman, 1914
3.55

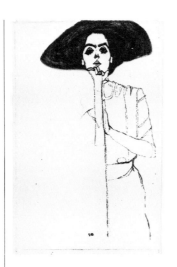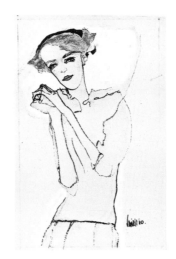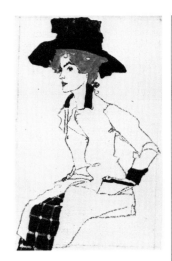

in a work such as *Mother and Child II* of 1912.

Unfortunately, the erotic poses in which Schiele frequently depicted his child models brought him into conflict with the law, and have to some extent coloured our perception of his work as a whole. But what Freud called 'the misunderstood and much-maligned erotic' is only one element in Schiele's art, albeit an important one, tempting us to overlook the meticulous attention he paid to portraiture and landscape, or the fact that his depictions of the urban environment, for example his frequent studies of his mother's birthplace, Krumau (pl. 22), rank among the most important manifestations of Expressionist painting produced anywhere at this time. As for Klimt, eroticism, subjects such as intercourse and masturbation remained for Schiele an enduring source of artistic inspiration, as some of the drawings produced in the very last year of his life attest. But his later paintings also display an even greater concern with order, with

intricate structure, an even greater solidity which makes it difficult for us to envisage how his art might have developed, had not Schiele's tragically early death robbed European painting of one of its most significant, only partially fulfilled talents.

Figure 73
Egon Schiele
Three postcards, 1910
3.50

3.1 Gustav Klimt
Hermine Gallia, 1904
Oil
170.5 × 96.5 cm
National Gallery, London (Inv. No. 6434)
Begun in 1903, the picture was shown, still
incomplete, at the Klimt retrospective
exhibition at the Secession (eighteenth
Vienna Secession exhibition) the same year.

3.2 Gustav Klimt
Drawing for the portrait of Hermine Gallia,
1903
Pencil
45 × 30 cm
Piccadilly Gallery, London

3.3 Gustav Klimt
Drawing for the portrait of Margaret
Stonborough-Wittgenstein, 1905
Pencil
54.5 × 34 cm
Private collection

3.4 Gustav Klimt
Drawing for *The Bride,* 1918
Pencil
56.5 × 37.3 cm
Viktor Fogarassy, Graz

3.5 *Die Hetaerengespräche des Lukian*
With fifteen drawings by Gustav Klimt
Leipzig, 1907
Professor and Mrs Christian M. Nebehay,
Vienna
This copy bound in suede leather, with gold
impression on front cover, in dust jacket,
No. 97 of 450 numbered copies.

3.6 and 7 Carl Otto Czeschka
Two designs for bronze reliefs in the Palais
Stoclet
Black chalk, ink, wash and white
heightening
Each 20 × 44 cm
Oesterreichisches Museum für angewandte
Kunst, Vienna (Inv. No. K.I. 10.403 a & b)
In 1904 the Belgian industrialist Adolphe
Stoclet commissioned Josef Hoffmann and
the Wiener Werkstätte to build, furnish and
decorate for him and his family an entire
town palace in the suburbs of Brussels. Most
of the work was completed during the
period 1905-11.

3.8 *Die Nibelungen*
With colour lithographs by Carl Otto
Czeschka
Vienna and Leipzig, c.1905
Historisches Museum der Stadt Wien (Inv.
No. 114107)
An illustrated children's book, published as
Volume 22 of Gerlach's *Jugendbücherei.*

3.9 *Giovanni Segantini*
By Franz Servaes
Vienna, 1902
Galerie Michael Pabst, Munich - Vienna
Monograph with original binding by Kolo
Moser.

3.10 Wiener Werkstätte
Wie ich es sehe
By Peter Altenberg
Berlin, 1904
Professor and Mrs Christian M. Nebehay,
Vienna
With original Wiener Werkstätte binding,
and in original case.

3.11 Wiener Werkstätte
Sample of wrapping paper
Mounted, 31 × 32 cm
Fischer Fine Art Ltd., London

3.12 Wiener Werkstätte
Four pattern designs

 a. Gouache
 16.3 × 15.3 cm

 b. Watercolour
 13.9 × 12.9 cm

 c. Indian ink
 15.5 × 8 cm

 d. Gouache
 12 × 16 cm

Fischer Fine Art Ltd., London

3.13 Josef Hoffmann
Two designs for jewellery
Pen and ink and watercolour
Together 53 × 47 cm
Professor and Mrs Christian M. Nebehay,
Vienna

3.14 Josef Hoffmann
Oval basket
Silver
Length 27.8 cm
Fischer Fine Art Ltd., London

3.15 Josef Hoffmann
Coffee set, c.1909
Electroplate

 a. Coffee pot with ebony handle
 15.5 × 19.5 × 10 cm

 b. Cream jug with ebony handle
 14.7 × 7.2 × 6 cm

 c. Sugar basin with lid
 8.2 × 6.2 × 7.9 cm

British Museum (Inv. No. M&LA 1982.
1-7. 1-3)
Designed by Hoffmann and made by Otto
Prutscher in the workshops of the Wiener
Werkstätte.

3.16 Wiener Werkstätte
Six vases, attributed to Michael Powolny
and Josef Hoffmann
Glass
Fischer Fine Art Ltd., London

3.17 Josef Hoffmann
Armchair, *c.*1906
Oak, polished black, with original
upholstery
Height 87 cm
Fischer Fine Art Ltd., London

3.18 Koloman (Kolo) Moser
Table, *c.*1903
Beech, painted white and black
Height 73 cm
Fischer Fine Art Ltd., London

3.19 Koloman (Kolo) Moser
Vase
Earthenware
22.1 × 19.5 cm
Victoria & Albert Museum, London (Inv.
No. C7 - 1982)

3.20 Leopold Forstner
*Mosaic with Scrolls, c.*1908
Coloured mosaic on cement
200.7 × 45.8 cm
Fischer Fine Art Ltd., London
Executed under Forstner's supervision by
the Mosaic Workshop at Stockerau, near
Vienna.

3.21 Bertold Löffler
Pallas Athene, 1908
Ceramic figure
Height 33.6 cm
City Art Gallery, Manchester

3.22 Michael Powolny
*Boy on a Snail, c.*1907
Earthenware
Height 18.5 cm
Victoria & Albert Museum, London (Inv.
No. Circ. 604 - 1966)
Made at the Wiener Keramik-Werkstätte.

3.23 Michael Powolny
Figure of a young lady, standing
Earthenware
Height 29 cm
Fischer Fine Art Ltd., London

3.24 Michael Powolny
Centrepiece
Earthenware
19.1 × 22 cm
Victoria & Albert Museum, London (Inv.
No. C8-1982)

3.25 Michael Powolny
*Female figure, c.*1910
Earthenware
Height 28.5 cm
Victoria & Albert Museum, London (Inv.
No. Circ. 524 - 1974)
Made by the Vienna and Gmunden Ceramic
Co. Ltd.

3.26 Adolf Loos
Chest of drawers, 1899-1900
Maple with brass fittings
134.5 × 100 × 57 cm
Victoria & Albert Museum, London (Inv.
No. W19 - 1982)
Part of a suite of bedroom and dressing
room furniture designed for the Turnowsky
family flat in the Wohllebengasse.

3.27 Adolf Loos
Chair
Walnut with brass fittings
Height 74 cm
Fischer Fine Art Ltd., London

3.28 *Das Andere*
Edited by Adolf Loos
Volume I, No. 1 (1903)
Stadtbibliothek, Vienna

3.29 Three drawings for Adolf Loos's
house Goldman und Salatsch (*Haus am
Michaelerplatz*), 1910

 a. alternative project for the main
facades
pencil, pen and ink and watercolour
38 × 78.5 cm

 b. redesigned project for the main
facades
pen and ink
42.5 × 81.5 cm

 c. ground plan
pen and ink, watercolour and wash
35.5 × 57 cm

Plan- und Schriftenkammer des Magistrats
der Stadt Wien
The two facade drawings are dated (a) 25
July 1910 and (b) 27 December 1910 and bear
the signature of the architect Ernst Epstein;
the name Adolf Loos does not appear on any
of the plans or drawings for the house. The
more traditional appearance of the windows
in the redesigned project (b) reflects the
intervention of the architect and town
councillor Hans Schneider, who had
opposed the bare, undecorated facades of
Loos's earlier scheme.

3.30 Adolf Loos
Poster advertising a lecture, 1911
Colour lithograph
80 × 58.5 cm
Oesterreichisches Museum für angewandte
Kunst, Vienna (Inv. No. P.I. 1830)
Loos's lecture in defence of his *Haus am
Michaelerplatz* was given on 11 December
1911 under the auspices of the Academic
Society for Literature and Music.

3.31 Oskar Kokoschka
Adolf Loos, 1909
Oil
74 × 91 cm
Nationalgalerie, Berlin

3.32 Oskar Kokoschka
Karl Kraus, 1909
Brush and ink
29.5 × 20 cm
Walter Feilchenfeldt, Zürich

3.33 Alfred Hagel
Sheet of drawings of Karl Kraus
Pencil
19 × 12 cm
Historisches Museum der Stadt Wien (Inv.
No. 72842/14)

3.34 *Die Fackel*
Edited by Karl Kraus

 a. No. 53, September 1900

 b. No. 300, April 1910

Dr E. F. Timms, Cambridge

3.35 Richard Gerstl
The Palais Liechtenstein, seen from the artist's studio, c.1905
Oil
55.5 × 69 cm
Historisches Museum der Stadt Wien (Inv. No. 53 671)

3.36 Richard Gerstl
Small Garden Landscape
Oil
35 × 34.2 cm
Viktor Fogarassy, Graz

3.37 Richard Gerstl
Vienna, View on to the Street
Oil
35.8 × 29 cm
Viktor Fogarassy, Graz

3.38 Richard Gerstl
Self Portrait with Easel
Oil
68.5 × 55.5 cm
Viktor Fogarassy, Graz

3.39 Arnold Schoenberg
Garden at Mödling, c.1908
Oil
71 × 49 cm
Lawrence A. Schoenberg, Los Angeles

3.40 Arnold Schoenberg
Red Gaze, 1910
Oil
28 × 22 cm
Lawrence A. Schoenberg, Los Angeles

3.41 Arnold Schoenberg
Gaze, 1910
Oil
28 × 20 cm
Lawrence A. Schoenberg, Los Angeles

3.42 Arnold Schoenberg
Gaze
Oil
23 × 18 cm
Lawrence A. Schoenberg, Los Angeles

3.43 Egon Schiele
Seated Male Nude, 1910
Oil
152.5 × 150 cm
Dr Rudolf Leopold, Vienna (L 145)

3.44 Egon Schiele
Mother and Child II, 1912
Oil on wood
36.5 × 29.2 cm
Dr Rudolf Leopold, Vienna (L 207)

3.45 Egon Schiele
Windmill 1824, 1907
Watercolour
17 × 11 cm
Internationale Egon Schiele-Gesellschaft, Tulln, Austria

3.46 Egon Schiele
Marie Schiele with Fur Collar, 1907
Watercolour and body colour
33 × 22.3 cm
Internationale Egon Schiele-Gesellschaft, Tulln, Austria

3.47 Egon Schiele
Houses at Krumau, 1908
Coloured chalks
29.5 × 30.5 cm
Piccadilly Gallery, London

3.48 Egon Schiele
Girl with Red Hair putting on Boots, 1909
Mixed media
30 × 30 cm
Viscountess Stuart of Findhorn

3.49 Egon Schiele
Self Portrait, 1910
Colour lithograph
45 × 32.5 cm
Victoria & Albert Museum, London (Inv. No. Circ. 665 - 1962)

3.50 Egon Schiele
Three postcards, 1910
Colour lithographs
Each 120 × 90 mm
Oesterreichisches Museum für angewandte Kunst, Vienna (Inv. No. K.I. 13.749/20a-c)
Published by the Wiener Werkstätte.

3.51 Egon Schiele
Self Portrait, standing
Watercolour and pencil
47.5 × 30.7 cm
Viktor Fogarassy, Graz

3.52 Egon Schiele
Girl with Elbow Raised, 1911
Watercolour and pencil
48 × 30 cm
Fischer Fine Art Ltd., London

3.53 Egon Schiele
Manuscript draft of a prose poem, 1911
Stadtbibliothek, Vienna (Inv. No. 180.641)

3.54 Egon Schiele
Farmhouse, 1913
Watercolour
30.8 × 46.5 cm
Viktor Fogarassy, Graz

3.55 Egon Schiele
Seated Woman, 1914
Pencil
48 × 32 cm
Robert Gore Rifkind Foundation, Los Angeles

3.56 Egon Schiele
Female Nude, 1918
Black chalk
Lord Weidenfeld, London

3.57 Emil Hoppe
Three views of the *Kunstschau 1908*
Colour lithographs
Each 120 × 90 / 90 × 120 mm
Oesterreichisches Museum für angewandte Kunst, Vienna
From a series of postcards of architectural subjects published by the Wiener Werkstätte.

3.58 Emil Hoppe
View of the *Kunstschau 1908*
Colour lithograph
90 × 120 mm
Victoria & Albert Museum, London (Inv. No. Circ. 494-1972)
One of a series of Wiener Werkstätte postcards.

3.59 Rudolf Kalvach
Design for a poster advertising the
Kunstschau 1908
Gouache
124 × 47 cm
Fischer Fine Art Ltd., London

3.60 Bertold Löffler
Poster advertising the *Kunstschau 1908*
Colour lithograph
36.5 × 50 cm
Galerie Michael Pabst, Munich - Vienna

3.61 Oskar Kokoschka
Poster advertising the *Kunstschau 1908*
Colour lithograph
95.5 × 52.2 cm
Oesterreichisches Museum für angewandte
Kunst, Vienna (Inv. No. P.I. 1129)

3.62 *Die Träumenden Knaben*
By Oskar Kokoschka
Volume ot poems and colour lithographs
Vienna 1908
British Museum
Kokoschka's children's book *The Dreaming
Youths* was published by the Wiener
Werkstätte, and exhibited at the *Kunstschau
1908*.

3.63 Oskar Kokoschka
Four plates from *Die Träumenden Knaben*,
1908
Colour lithographs
In pairs, each pair 66.1 × 52.2 cm
Margaret Fisher, London

3.64 Oskar Kokoschka
Poster advertising the *Sommertheater in der
Kunstschau 1909*
Colour lithograph
120.5 × 79 cm
Oesterreichisches Museum für angewandte
Kunst, Vienna (Inv. No. P.I. 1802)
The subject of the poster is related to
Kokoschka's play *Murderer Hope of Women*,
first performed at the *Kunstschau* in July
1909.

3.65 Oskar Kokoschka
Murder of a Woman, 1908-9
Pencil, ink and watercolour
30.8 × 25 cm (irregular)
Robert Gore Rifkind Foundation, Los
Angeles

3.66 *Mörder Hoffnung der Frauen*
By Oskar Kokoschka
In *Der Sturm,* Berlin, 1910
Staatsbibliothek, Berlin
Kokoschka's play *Murderer Hope of Women*
and three related drawings were published in
Herwarth Walden's periodical *Der Sturm* on
14 July, 21 July and 11 August 1910.

3.67 Oskar Kokoschka
Poster advertising a lecture, 1911
Colour lithograph
91.6 × 55 cm
Fischer Fine Art Ltd., London
Kokoschka's lecture 'On the Nature of
Visions' was given under the auspices of the
Academic Society for Literature and Music
in Vienna on 26 January 1912.

3.68 *Die chinesische Mauer*
By Karl Kraus
With eight lithographs by Oskar Kokoschka
Leipzig, 1914
Galerie Michael Pabst, Munich - Vienna
Kokoschka's illustrations for Kraus's fable
The Great Wall of China were probably
completed in the course of 1913.

3.69 Oskar Kokoschka
Four postcards
Colour lithographs
Each 120 × 90 mm
Oesterreichisches Museum für angewandte
Kunst, Vienna
Published by the Wiener Werkstätte

3.70 Moriz Jung
Two postcards
Colour lithographs
Each 120 × 90 mm
Oesterreichisches Museum für angewandte
Kunst, Vienna
Published by the Wiener Werkstätte

Imperial Jubilee Pageant 1908

3.71 Booklet containing order of events
and description of the pageant held on 12
June 1908 to mark the 60th anniversary of
Emperor Franz Joseph's accession to the
throne
Dr Wilhelm Schlag, Vienna
In modern binding.

3.72 Booklet containing a selection of
photographs of the pageant on 12 June 1908
Dr Wilhelm Schlag, Vienna
In modern binding.

3.73 Booklet, with photographs (another
copy)
Historisches Museum der Stadt Wien (Inv.
No. 124345)

3.74 Brochure
With cover by Rudolf Junk
Historisches Museum der Stadt Wien (Inv.
No. 123994/1)

3.75 Seventeen postcards published by the
Wiener Werkstätte, showing scenes from
the pageant of 12 June 1908, by Remigius
Geyling, Hubert von Zwickle, Bertold
Löffler, Josef Diveky
Colour lithographs
Mounted together, 63 × 125 cm
Oesterreichisches Museum für angewandte
Kunst, Vienna

3.76 Ludwig Ferdinand Graf
Poster advertising the pageant of June 1908
Colour lithograph
126 × 95.5 cm
Historisches Museum der Stadt Wien (Inv.
No. 115834)

3.77 Bertold Löffler
Poster 'Grandes fêtes . . . de l'Empereur',
1908
Colour lithograph
104 × 38 cm
Fischer Fine Art Ltd., London

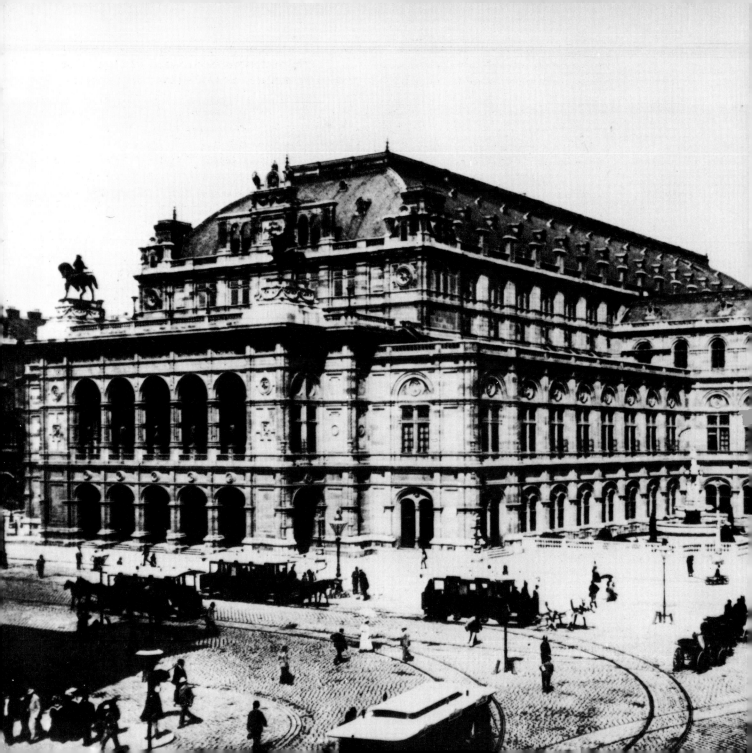

Even apart from artists like Schoenberg who deliberately crossed the boundaries separating one art from another, the first decade of this century witnessed an extraordinary growing together of the different arts, especially painting and music. Painters began to concern themselves with musical subjects, with allegories and depictions of music or, at a more mundane level, with painting portraits of composers and musicians. But some artists went further, envisaging a kind of fusion or synthesis of the arts whose effect would somehow transcend that produced by any single art—a whole greater than the sum of its parts. The obvious place for the realisation of this ideal was on the operatic stage.

In its modern form, this notion of the *Gesamtkunstwerk* or 'total work of art' goes back to Richard Wagner, who conceived of his own music dramas as a kind of monumental ritual embracing music, speech, costume, decor and so on. He himself does not, however, appear to have been especially sensitive to the visual arts, and as far as the staging of his works was concerned demanded nothing more than a somewhat overblown but still conventional naturalism which depended on the customary props and painted scenery. Nor was there among the stage designers of his own day an artist whose innovative vision might be measured against Wagner's musical genius. Not until the 1890s did a new generation of artists come to maturity, capable of looking afresh at the visual implications of the musical revolution Wagner had initiated.

Of these younger artists, one of the most radical was the Swiss designer Adolphe Appia. Appia conceived bare, sparse settings for Wagner's operas, discarding the accretions of tradition in a way that anticipates by more than half a century Wieland Wagner's 'revolutionary' Bayreuth productions of the 1960s. Not that his ideas found any favour in turn-of-the-century Bayreuth: on the contrary, Cosima Wagner did everything she could to block the young artist's career, likening his designs to the drawings the explorer Nansen had brought back from the North Pole. Appia's theories, on the other hand, published in German in 1899 under the title *Die Musik und die Inszenierung* (Music and Staging), were read with close interest by another genius whose career provoked just as much opposition as Appia's, but who in 1897 against all the odds had been appointed director of the Imperial and Royal Court Opera in Vienna: Gustav Mahler.

Mahler's stature as a composer has tended to eclipse memories of Mahler the conductor; but the 'Mahler era' at the Vienna Opera from 1897 to 1907 was one of the outstanding periods in the history of that theatre. Mahler brought to Vienna singers from all over Europe, tempting them away from other opera houses such as Hamburg and Berlin and assembling a team which boasted some of the greatest dramatic voices of the early years of this century: Anna von Mildenburg, who later married the critic and essayist Hermann Bahr, Marie Gutheil Schoder, Selma Kurz, Erik Schmedes, Richard Mayr, Leo Slezak. In the voices of his prima donnas especially he looked for a purity and expressive power which found their counterpart in the fanatical clarity and precision Mahler demanded from the orchestra. He was a champion of new

Figure 74
Vienna, the Opera House Completed in 1869, the Vienna Opera is an example of that eclectic manner of building known as the Ringstrasse-style. In 1897, a new era began when Gustav Mahler was appointed director; his performances of Mozart's and Wagner's operas, with Alfred Roller's sets and costumes, have become legendary.

Figure 75
Arnold Schoenberg

Figure 76
Alban Berg

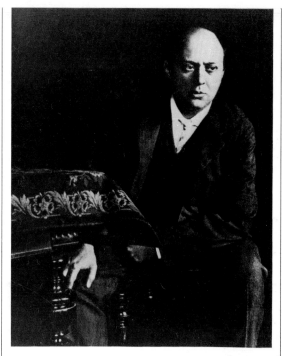

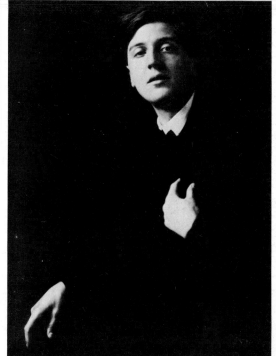

music and of younger composers like Zemlinsky and Schoenberg, and as far as possible introduced new works into the repertoire of the Court Opera even when, as in the case of Charpentier's *Louise*, it meant devising an entirely unconventional kind of staging which seems to have been at odds even with Mahler's own conceptions of what belonged on the operatic stage. He was, however, prevented from performing perhaps the most important new opera written during the period of his directorship, Strauss's *Salome*, forbidden by the censor on the grounds that the plot, based on Wilde's play, belonged in the realms of sexual pathology and not, under any circumstances, on the stage of the Court Opera.

But apart from championing new music, as a conductor Mahler devoted himself above all to the work of two composers: Mozart and Wagner. It was to conduct a performance of *Lohengrin* that he first stepped on to the podium of the Vienna Opera, and shortly after his appointment as director he took all performances of Wagner's music into his own hands. He was the first to give the *Ring of the Nibelung* entirely uncut in Vienna, adding more than an hour to the time hitherto taken to perform *Götterdämmerung*. In 1903 the Court Opera marked the twentieth anniversary of the composer's death by staging an entirely new production of *Tristan und Isolde* under Mahler's direction, with Mildenburg as Isolde and Schmedes as Tristan. But what

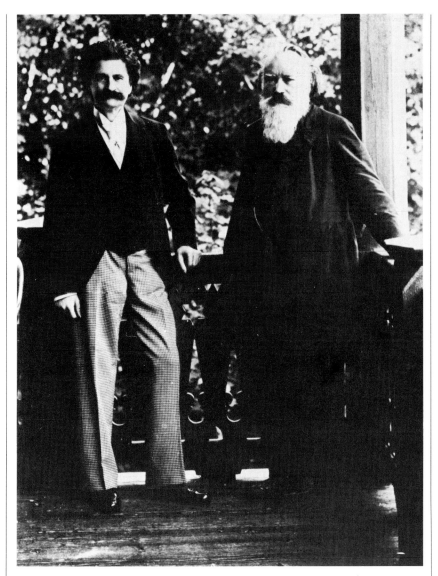

Figure 77
Johann Strauss and Johannes Brahms
Dissimilar though their music may have been, they had a high regard for one another, and met regularly to play tarot

The story of the decisive meeting between Mahler and Roller has been often retold, and is perhaps partly invented; but like many anecdotes, it is probably true in its essentials. Mahler had had little contact with the visual arts before his arrival in Vienna, but was introduced into Secessionist circles by the painter Carl Moll, step-father of Mahler's fiancée Alma Maria Schindler. Mahler became very friendly with the Secessionists, especially Klimt; but his attention was captured most of all by Roller. Roller, it seems, as soon as he had Mahler's ear lost no time in declaring that, frequent opera-goer though he was, he had never seen a production of *Tristan* that satisfied him visually, and went on to explain exactly how he envisaged the staging of Wagner's work. He also produced sketches of settings for the three acts and, encouraged by Mahler's enthusiasm, quickly worked them up into detailed designs. The 1903 production, already scheduled, provided the opportunity with Mahler's backing of translating these designs into reality. The visual impact was such that, despite Roller's lack of previous experience, Mahler felt able to appoint him as director of design at the opera, over the head of vastly experienced designers like Anton Brioschi and Heinrich Lefler.

Roller's engagement at the Court Opera in fact caused some resentment: Mahler himself referred to the other designers taking it 'with the best grace they could muster.' Brioschi, in particular, in collaboration with his father had been producing settings for Wagner's operas in Vienna for nearly two decades, and must have felt slighted by the intrusion of this novice. It is a mark of his patience and skill

created the greatest stir were the sets and costumes for this 1903 production, designed by a man with no previous experience of the operatic stage whatever: the Secessionist Alfred Roller.

Figure 78
C. O. Czeschka
Costume design for Tristan,
1908
4.13a

Figure 79
C. O. Czeschka
Costume design for Wotan,
1908
4.13b

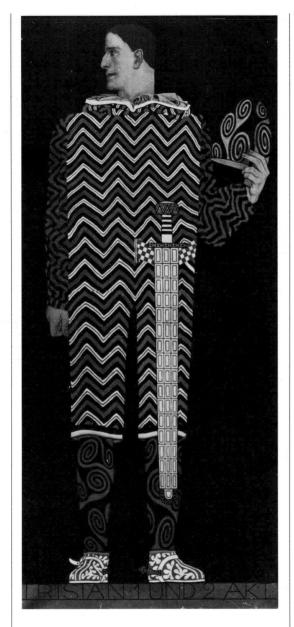

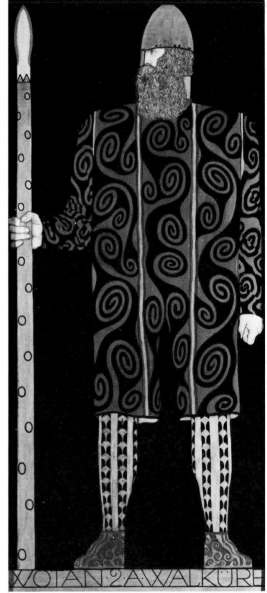

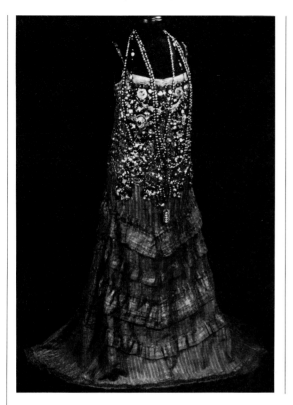

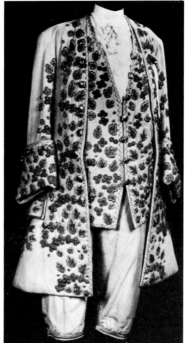

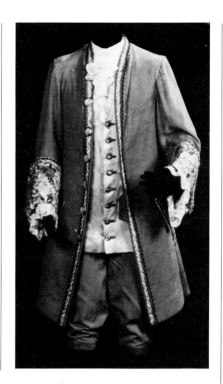

that he was none the less able to turn from his own rather grandiose, naturalistic conceptions to the task of executing designs after Roller's sketches as in the case of *Rosenkavalier*, for example.

There was, however, no doubting Roller's gifts. In many respects, he was the operatic designer Appia's theories demanded. He conceived of the stage as a three-dimensional space and treated it as such, rather than relying on painted flats to create the illusion of depth. He looked at the text with fresh eyes, isolating the dramatic essentials, exploring the symbolism of light and darkness, for example, implicit in the libretto of *Tristan*.

Above all, he used light as an expressive element. Numerous contemporary reviews refer to the way in which he 'painted with light', using lighting to enhance the dramatic unity by casting a whole act, for example, in a certain colour tonality. This device did not always meet with the approval of the critics: one review of *Tristan* described the first act as 'orange-yellow, the second mauve and the third dough-coloured.' It did, however, correspond exactly to Mahler's conception of opera as, in the words of an American critic, 'not a collection of set pieces for singers but a drama in music.'

The collaboration between Mahler as

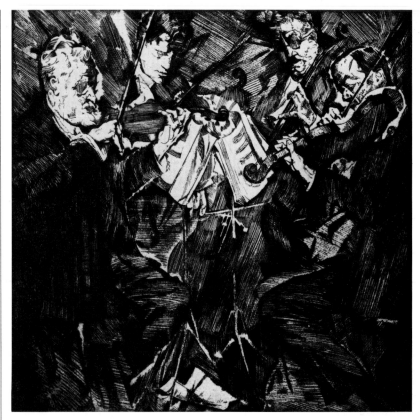

musical director and Roller as head of design was the most important feature of the second half of Mahler's reign at the Vienna Opera. Together, they staged new productions of Beethoven's *Fidelio* (1904), Mozart's *Don Giovanni* (1905) and embarked on a complete *Ring* cycle of which only the first two operas, *Rheingold* (1905) and *Walküre* (1906) were given under Mahler's directorship. Ironically, the most Viennese of all operas, Strauss's *Rosenkavalier*, with Roller's costumes and settings, received its world première not in Vienna but in Dresden, on 26 January 1911, under the baton of Ernst von Schuch; its first Viennese performance took place the same year under Franz Schalk.

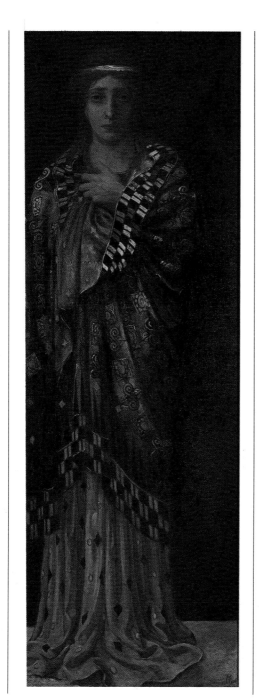

Figure 83
Max Oppenheimer
The Rosé Quartet, 1928
4.25

Figure 84
Emil Orlik
Richard Wagner, 1898
4.26

Figure 85
Emil Orlik
Richard Strauss, 1917
4.29

Plate 27
Franz Matsch (?)
Anna von Mildenburg as Isolde
4.1

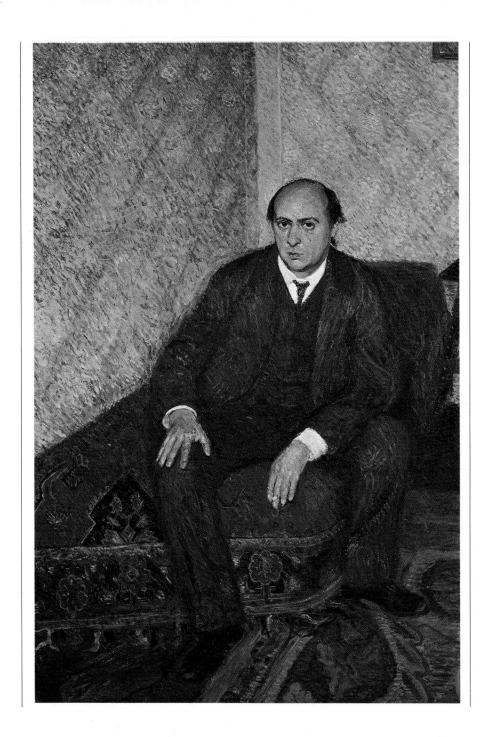

Plate 28
Richard Gerstl
Arnold Schoenberg
4.33

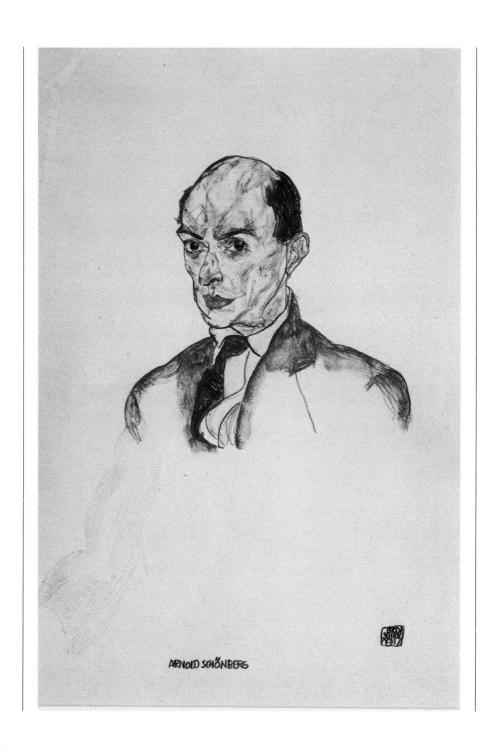

ARNOLD SCHÖNBERG

Plate 29
Egon Schiele
Arnold Schoenberg, 1917
4.34

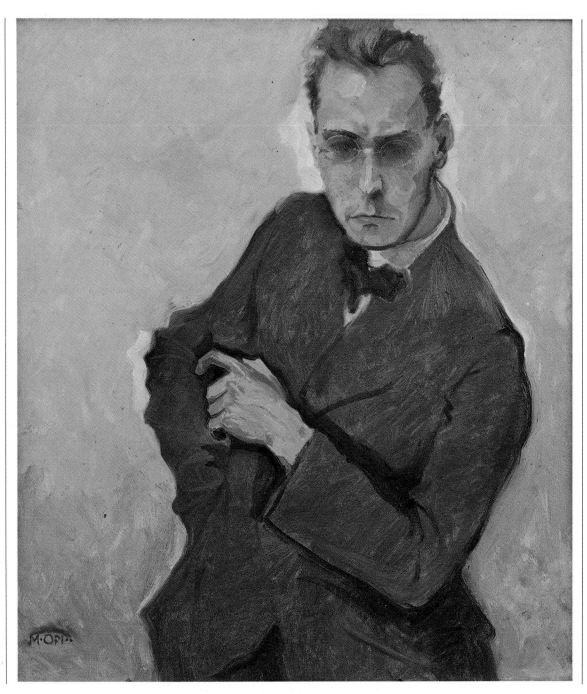

Plate 30
Max Oppenheimer
Anton von Webern, 1910
4.48

4.1 Franz Matsch (?)
Anna von Mildenburg as Isolde
Oil
259 × 65 cm
Theatersammlung der Oesterreichischen
Nationalbibliothek, Vienna (Inv. No.
0-203)

4.2 Four photographs of Anna
Bahr-Mildenburg as Isolde, 1902
Theatersammlung der Oesterreichischen
Nationalbibliothek, Vienna (Inv. No. PK
47, 48, 49, 642)

4.3 Photograph of Anna von Mildenburg
as Isolde in Roller's 1903 production
Theatersammlung der Oesterreichischen
Nationalbibliothek, Vienna (Inv. No. PG
56)

4.4 Six photographs of Erik Schmedes as
Tristan, 1903
Theatersammlung der Oesterreichischen
Nationalbibliothek, Vienna (Inv. No. PP
114, 119, 121, 122, 146, 147)

4.5 Handbill for performance of *Tristan
und Isolde* at the k.k. Hofoper, Vienna, 21
February 1903
Theatersammlung der Oesterreichischen
Nationalbibliothek, Vienna

4.6 Alfred Roller
Stage model for *Tristan und Isolde,* Act III
Theatersammlung der Oesterreichischen
Nationalbibliothek, Vienna (Inv. No. M
366)
The premiere of Roller's production of
Tristan und Isolde was given under Gustav
Mahler on 21 February 1903.

4.7 Alfred Roller
Four designs for *Tristan und Isolde*, Acts I and
II, 1903
Mixed media
On one sheet, 27.7 × 43.1 cm
Theatersammlung der Oesterreichischen
Nationalbibliothek, Vienna (Inv. No. HÜ
15693)

4.8 Alfred Roller
Design for costume of Isolde, 1903
Mixed media
42.1 × 19.6 cm
Theatersammlung der Oesterreichischen
Nationalbibliothek, Vienna (Inv. No. HÜ
16384)

4.9 Carlo Brioschi
Two set designs for *Götterdämmerung*

 a. The Hall of the Gibichungen (Act I,
Scene 2)
pencil and watercolour
26.5 × 35.9 cm

 b. The Hall of the Gibichungen (Act III,
Scene 3)
pencil, watercolour and white
heightening
26.3 × 37.6 cm
Theatersammlung der Oesterreichischen
Nationalbibliothek, Vienna (Inv. No.
HOpÜ 5055 & 5058)

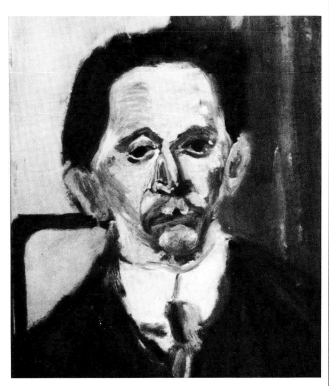

Figure 86
Arnold Schoenberg
Alexander von Zemlinsky
4.45

4.10 Anton Brioschi
Three set designs for *Götterdämmerung*

 a. Valhalla
pencil, watercolour and white
heightening
26 × 36.8 cm

 b. Valhalla
pencil and watercolour
30 × 43.9 cm

 c. The Hall of the Gibichungen
pencil and watercolour
25.7 × 33.2 cm
Theatersammlung der Oesterreichischen
Nationalbibliothek, Vienna (Inv. No.
HOpÜ 5059, 5056, 5054)

4.11 Anton Brioschi
Set design for *Rosenkavalier*, Act I
Pencil and watercolour
21.8 × 44 cm
Theatersammlung der Oesterreichischen
Nationalbibliothek, Vienna (HÜ 31099)

4.12 Carl Otto Czeschka
Two designs for *Walküre*

 a. for costume of Sieglinde
pen and ink and watercolour
40.5 × 30.4 cm

 b. for costume of Wotan
pen and ink and watercolour
42 × 31.9 cm

Theatersammlung der Oesterreichischen
Nationalbibliothek, Vienna (Inv. No. 9989
c.a. & 9974 c.a.)

4.13 Carl Otto Czeschka
Two costume designs, 1908

 a. for Tristan in *Tristan und Isolde*

 b. for Wotan in *Walküre*

Tempera
Each 200 × 89 cm
Oesterreichisches Museum für angewandte
Kunst, Vienna (Inv. No. LHG 185 & 186)

4.14 Alfred Roller
Design for costume of Wotan in *Rheingold*
Mixed media
41.2 × 19.5 cm
Theatersammlung der Oesterreichischen
Nationalbibliothek, Vienna (Inv. No. HÜ
19326)

4.15 Alfred Roller
Design for costume of Sieglinde in *Walküre*,
1905
Mixed media
41.7 × 20 cm
Theatersammlung der Oesterreichischen
Nationalbibliothek, Vienna (Inv. No. HÜ
15861)

4.16 Alfred Roller
Four set designs for *Götterdämmerung*

 a. The Hall of the Gibichungen
mixed media
30.2 × 47.2 cm

 b. Forest glade on the banks of the Rhine
mixed media
30 × 47 cm

 c. Siegfried's funeral cortege
mixed media
30 × 47.2 cm

 d. Before the Hall of the Gibichungen
mixed media
30 × 47.2 cm

Theatersammlung der Oesterreichischen
Nationalbibliothek, Vienna (Inv. No. HÜ
15878, 15879, 15880, 15881)

4.17 Costume for *Lohengrin*
Theatersammlung der Oesterreichischen
Nationalbibliothek, Vienna (Inv. No.
02672)
Costume for Leo Slezak as Lohengrin, 1905.

4.18 Alfred Roller
Costume for Klytemnestra in *Elektra*
Theatersammlung der Oesterreichischen
Nationalbibliothek, Vienna (Inv. No.
0-2754)
Costume made for Anna Bahr-Mildenburg,
1909.

4.19 Alfred Roller
Stage model for *Rosenkavalier*, Act I
Theatersammlung der Oesterreichischen
Nationalbibliothek, Vienna (Inv. No. K
124)
The Viennese premiere of *Rosenkavalier*,
with Roller's sets and costumes, was given
on 8 April 1911.

4.20 Alfred Roller
Set design for *Rosenkavalier*, Act I, 1911
Mixed media
Theatersammlung der Oesterreichischen
Nationalbibliothek, Vienna (Inv. No. HÜ
15539)

4.21 Alfred Roller
Four costume designs for *Rosenkavalier*,
1911

 a. for the Marschallin in Act III
pencil and watercolour
39.4 × 18.9 cm

 b. for Octavian in Act I
pencil and watercolour
39.9 × 19.6 cm

 c. for Baron Ochs in Act II
pencil and watercolour
40.2 × 19.5 cm

 d. for Faninal in Act II
pencil and watercolour
40.2 × 19.5 cm

Theatersammlung der Oesterreichischen
Nationalbibliothek, Vienna (Inv. No. HÜ
19041, 15544, 15547, 15545)

4.22 Alfred Roller
Three costumes for *Rosenkavalier*

 a. Baron Ochs
costume for Richard Mayr, 1911

 b. Singer, 1911

 c. Octavian
costume for Jarmila Novotná, *c*.1930

Theatersammlung der Oesterreichischen
Nationalbibliothek, Vienna (Inv. No.
0-2512, 0-2741, 0-4689)

4.23 Ernst Stöhr
The Bass Fiddle, 1908
Oil
53 × 47 cm
Oesterreichische Galerie, Vienna (Inv. No. 4785)

4.24 Fritz von Herzmanovsky-Orlando
Music-making peasants
Pen and bistre wash
20 × 16 cm
Georg Eisler, Vienna

4.25 Max Oppenheimer
The Rosé Quartet, 1932
Etching
27.5 × 35 cm
British Museum (Inv. No. P&D 1934.2-19.2)
The quartet led by the violinist Arnold Rosé were among the foremost interpreters of Schoenberg's music.

4.26 Emil Orlik
Richard Wagner, 1898
Gold impression on postcard
9 × 14 cm
British Museum (Inv. No. 1949.4-11.3991)

4.27 Emil Orlik
Gustav Mahler, 1902
Mezzotint
29.4 × 20 cm
Ostdeutsche Galerie, Regensburg

4.28 Auguste Rodin
Gustav Mahler, 1909
Bronze
Height 33 cm
Kunsthistorisches Museum, Neue Galerie, Vienna (Inv. No. NG Pl 7)

4.29 Emil Orlik
Richard Strauss, 1917
Etching
44 × 34.5 cm
British Museum (Inv. No. P&D 1980.7-26.39)

4.30 Arnold Schoenberg
Alban Berg
Oil
172 × 84 cm
Historisches Museum der Stadt Wien

4.31 Portrait photograph of Alban Berg, *c.*1912
Oesterreichische Nationalbibliothek, Bildarchiv und Porträtsammlung, Vienna

4.32 Portrait photograph of Arnold Schoenberg, 1912
Arnold Schoenberg Institute, University of Southern California, Los Angeles

4.33 Richard Gerstl
Arnold Schoenberg
Oil
175 × 118 cm
Historisches Museum der Stadt Wien

4.34 Egon Schiele
Arnold Schoenberg, 1917
Watercolour, tempera and black chalk
40.5 × 27 cm
The Earl of Harewood

4.35 'Song of the Wood Dove', from *Gurrelieder*
By Arnold Schoenberg
Chamber version, 1922
Arnold Schoenberg Institute, University of Southern California, Los Angeles
Cover and first page of MS score.

4.36 *Erwartung,* 1909
Libretto by Marie Pappenheim
Arnold Schoenberg Institute, University of Southern California, Los Angeles
One page, with annotations by Schoenberg.

4.37 *Erwartung,* 1909
By Arnold Schoenberg
Arnold Schoenberg Institute, University of Southern California, Los Angeles
First page of the MS short score of Schoenberg's opera.

4.38 Arnold Schoenberg
Eight set designs for *Erwartung,* 1909

a. watercolour
10 × 17 cm

b. watercolour
17 × 11 cm

c. crayon, pastel and watercolour
32 × 25 cm

d. watercolour
14 × 24 cm

e. crayon, pastel and watercolour
26 × 31 cm

f. pastel and watercolour
31 × 45 cm

g. watercolour
10 × 17 cm

h. watercolour
33 × 48 cm

Lawrence A. Schoenberg, Los Angeles

4.39 *Harmonielehre,* 1911
By Arnold Schoenberg
Arnold Schoenberg Institute, University of Southern California, Los Angeles
Title page, dedication and page one of the MS of Schoenberg's *Theory of Harmony.*

4.40 *Der Merker*
1911, 3. Quartal (April-June)
British Library
Schoenberg issue (June 1911), with contributions by Richard Specht, Karl Linke, Rudolph Reti, reproductions of Schoenberg's paintings, the final chapter of his *Harmonielehre,* and the libretto of his opera *Die Glückliche Hand.*

4.41 *Der Blaue Reiter*
Edited by Kandinsky and Franz Marc
Munich (2nd edn.), 1914
British Library
The interest contemporary music held for Kandinsky and the artists of his circle is reflected in the *Blue Rider Almanac,* first published in 1912, which contained an essay by Arnold Schoenberg (see cat. no. **4.42**), reproductions of his paintings, and short pieces of music by Schoenberg, Berg and Webern.

4.42 'Das Verhältnis zum Text'
By Arnold Schoenberg
Published in *Der Blaue Reiter,* edited by
Kandinsky and Franz Marc, Munich, 1912
Arnold Schoenberg Institute, University of
Southern California, Los Angeles
Offprint of Schoenberg's article 'The
Relationship to the Text', with MS
corrections.

4.43 *Arnold Schönberg. Mit Beiträgen von
Alban Berg . . .*
Munich, 1912
Pendelbury Music Library, Cambridge
Containing essays by Albert Paris von
Gütersloh and Wassily Kandinsky on
Schoenberg's paintings.

4.44 Four photographs of Arnold
Schoenberg and Alexander von Zemlinsky,
*c.*1912
Arnold Schoenberg Institute, University of
Southern California, Los Angeles

4.45 Arnold Schoenberg
Alexander von Zemlinsky
Oil
49 × 34 cm
Lawrence A. Schoenberg, Los Angeles

4.46 Emil Orlik
Alexander von Zemlinsky
Lithograph
23 × 15 cm
Ostdeutsche Galerie, Regensburg

4.47 Josef Matthias Hauer
*Dance suite. Studies for piano, violin, viola,
cello and double bass*
Manuscript in ink and coloured crayons
Galerie Michael Pabst, Munich - Vienna

4.48 Max Oppenheimer
Anton von Webern, 1910
Oil
80 × 70 cm
Von der Heydt-Museum der Stadt
Wuppertal (Inv. No. G262)

4.49 Egon Schiele
Anton von Webern, 1918
Charcoal
47 × 30 cm
Viktor Fogarassy, Graz

4.50 Josef Humplik
Anton von Webern, 1928
Bronze
Height 36 cm
Oesterreichische Galerie, Vienna (Inv. No.
2889)

4.51 Bertold Löffler
Poster for the Kabarett Fledermaus, 1907
Colour lithograph
63 × 43.5 cm
Historisches Museum der Stadt Wien (Inv.
No. 115069/3)

4.52 Bertold Löffler
Poster for the Kabarett Fledermaus, 1907
Colour lithograph
95 × 63 cm
Historisches Museum der Stadt Wien (Inv.
No. 129129)

4.53 Kabarett Fledermaus
Two Wiener Werkstätte postcards depicting
the auditorium and bar room of the cabaret
Colour lithographs
140 × 90 / 90 × 140 mm
Victoria & Albert Museum, London (Inv.
No. Circ. 491 & 494 - 1972)

4.54 Kabarett Fledermaus
Fourteen postcards, by Fritz Zeymer, Josef
Diveky and Moriz Jung, depicting the
cabaret and its performers
Colour lithographs
Mounted together, 63 × 125 cm
Oesterreichisches Museum für angewandte
Kunst, Vienna
From a series of postcards of the Kabarett
Fledermaus, published by the Wiener
Werkstätte.

4.55 Kabarett Fledermaus
Programme book, 1907
Historisches Museum der Stadt Wien (Inv.
No. 115474)
With original cover by Carl Otto Czeschka,
containing illustrations by Bertold Löffler,
Fritz Zeymer and Oskar Kokoschka.

4.56 Kabarett Fledermaus
Programme book, 1907
Historisches Museum der Stadt Wien (Inv.
No. 115473)
With decorations by Carl Otto Czeschka
and illustrations by Moriz Jung.

4.57 Cabaret Nachtlicht
Album with original covers, containing
drawings by Carl Hollitzer and Ernst Stern
Galerie Michael Pabst, Munich - Vienna

4.58 Group photograph of the Wiesenthal
sisters, *c.*1907
Theatersammlung der Oesterreichischen
Nationalbibliothek, Vienna (Inv. No.
PÜÜ/148.084)
In the early 1900s the sisters Grete, Elsa and
Berta Wiesenthal became famous for their
natural and expressive manner of dancing —
not least through their appearances at the
Kabarett Fledermaus.

4.59 Six photographs of Grete Wiesenthal
Martin Lang, Vienna

4.60 Erwin Lang
*Grete Wiesenthal (The Blue Danube), c.*1908
Pen and ink
46 × 31.8 cm
Martin Lang, Vienna
In 1910 Grete Wiesenthal married the artist
Erwin Lang, who portrayed his wife in a
series of graceful drawings and illustrations.

4.61 *Grete Wiesenthal. Holzschnitte von
Erwin Lang*
With an introduction by Oskar Bie
Leipzig, 1910
Martin Lang, Vienna

Printed in Scotland for HMSO Dd. 735695